D0729215

Cool
CHICKENS

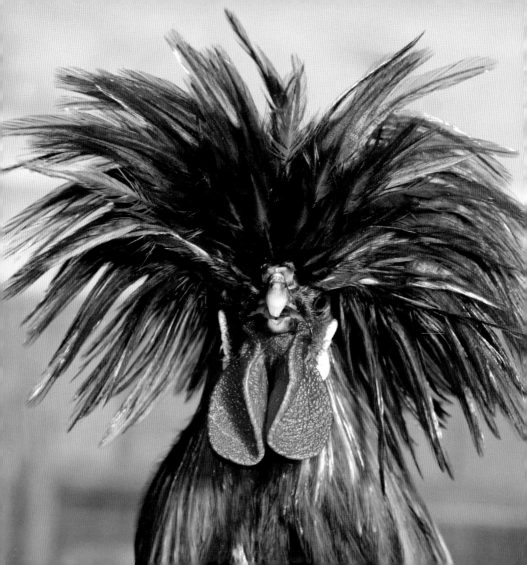

Cool

CHICKENS

Contributing Editor
FERN COLLINS

CHARTWELL
BOOKS

Quarto is the authority on a wide range of topics.

Quarto educates, entertains and enriches the lives of our readers—enthusiasts and lovers of hands-on living.

www.quartoknows.com

This edition published in 2016 by
CHARTWELL BOOKS
an imprint of The Quarto Group
142 West 36th Street, 4th Floor
New York, NY 10018
USA

Copyright © 2016 Regency House Publishing Limited
The Manor House
High Street
Buntingford
Hertfordshire
SG9 9AB
United Kingdom

All rights reserved. No part of this book may be reproduced in any form or by any electronic or mechanical means, including information, storage and retrieval systems, without prior written permission from the copyright holder.

ISBN-13: 978-0-7858-3450-2

10 9 8 7 6 5 4 3 2

Printed in China

For all editorial enquiries, please contact:
www.regencyhousepublishing.com

Images used under license from
©Shutterstock.com

This is a beginner's introduction to the fascinating world of chickens and chicken-keeping and, as such, is not intended to be a complete, detailed guide to the subject.

Every effort has been made to ensure that credits accurately comply with the information supplied. No responsibility is accepted by the producer, publisher, or printer for any infringement of copyright or otherwise, arising from the contents of this publication. We apologize for any inaccuracies that may have occurred and will resolve inaccurate or missing information in any subsequent reprint of the book.

MIX
Paper from responsible sources
FSC® C016973

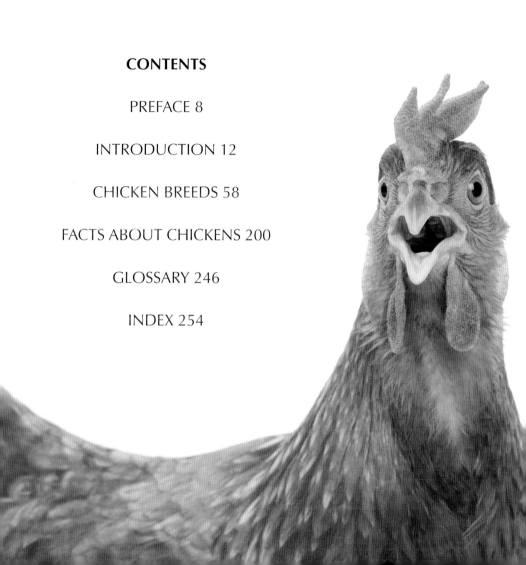

CONTENTS

PREFACE 8

INTRODUCTION 12

CHICKEN BREEDS 58

FACTS ABOUT CHICKENS 200

GLOSSARY 246

INDEX 254

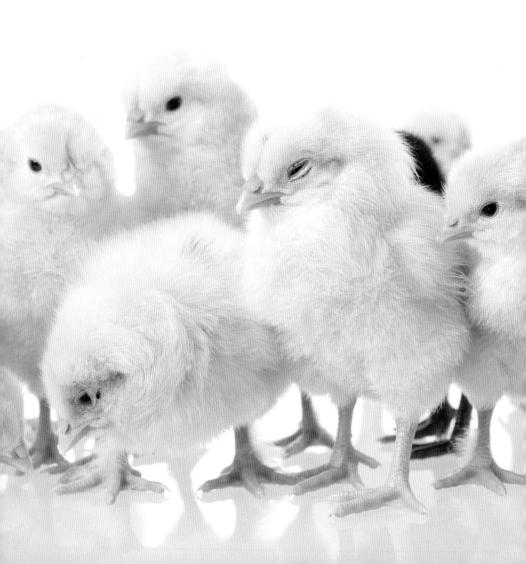

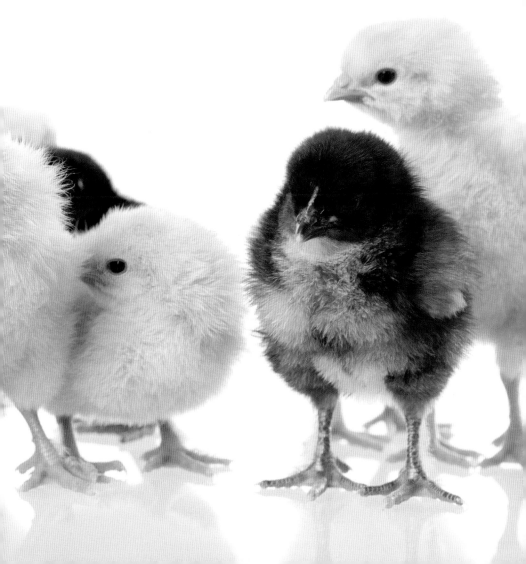

The chicken is one of the most ubiquitous of all the domestic animals, having been kept by humankind for thousands of years for its meat, eggs and feathers. It has also played – and continues to play – a part in religious ceremonies and other ancient rituals. Today, chickens can be found in almost every part of the world, and it is estimated that over 24 billion exist worldwide. Yet their exact origins are still open to speculation, despite our long and mutual association. In fact, they most likely stemmed from one of the breeds of Asian jungle fowl to which many chickens bear more than a passing resemblance.

The reasons for the chicken's wide appeal are easy to appreciate. To begin with, there are many types from which to choose, and most are hardy, breed readily, are easy to maintain, and are adaptable to different environments. Many breeds mature quickly, given the right conditions, rapidly putting on valuable weight, and some individuals may lay 200–300 eggs a year when in their prime. It is not surprising, therefore, that chickens have become the mainstay of enormous industries in many parts of the world, while these same qualities make them ideal for keeping on a smaller scale, simply to provide a family with eggs and meat. They are even regarded by some as ideal pets, the smaller, more docile breeds being perfect for introducing young children to the ways of animals in general.

When young, chickens are easily tamed and quickly become accustomed to being handled. In a short time they will reveal their own quirky characters to the amusement of

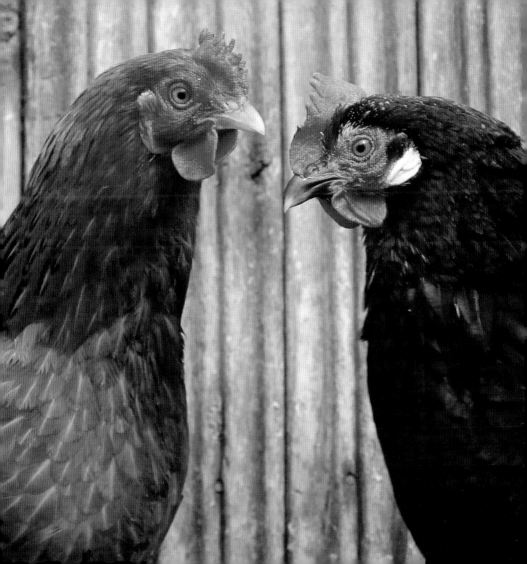

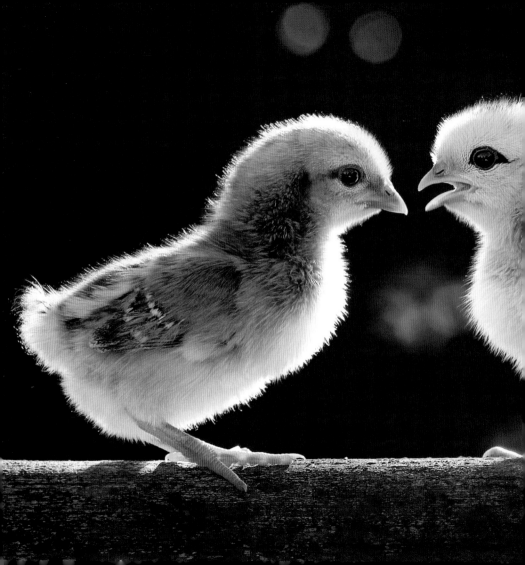

their owners, while usefully providing them with a welcome supply of breakfast eggs.

The aim of this book is simply to stimulate an initial interest in these fascinating creatures. While it is not intended to be an academic work, based on hard biological facts and detailed animal husbandry, it is more a treasury of interesting facts and illustrations, designed to whet the appetite and stimulate further interest into the lives of these charming, characterful birds.

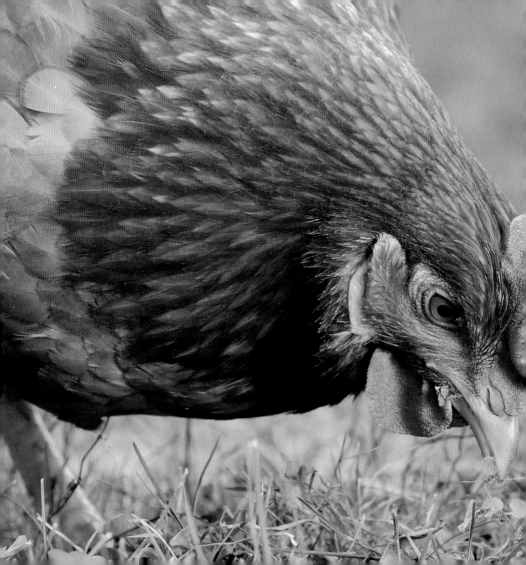

INTRODUCTION

Chickens and other poultry have been kept and reared in Europe for over 2,000 years, and have also long appeared in places as far apart as India and China. Today, there is hardly a place in the world that does not have thriving populations of domestic chickens, and it is easy to see why this should be so. Many chicken breeds are hardy and will also forage for themselves if necessary. They are quick to grow, mature, and feather up, and quickly come to a stage when they are capable of laying eggs or are ready for the table. Many chickens are capable of laying several hundred eggs in a year – with more than 300 possible in some breeds.

All of today's domestic chickens are believed to be descended from the Asian jungle fowl, of which four distinct types exist in the wild. It is possible the chicken could have derived from any one (or more) of these, although the candidate most strongly argued is the red jungle fowl (*Gallus gallus*), and one only

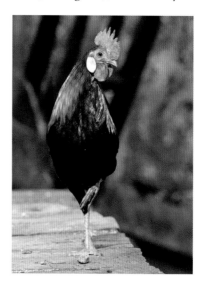

A red jungle fowl.

has to look at this to spot its resemblance to many of our modern domestic breeds, a similarity that is most strongly marked in cockerels or roosters (male birds).

The wild red jungle fowl is a common and locally widespread bird that ranges throughout much of Asia, from Nepal through India, then eastward and southward to China, Vietnam, and Indonesia. It ranges almost entirely over the tropical and subtropical regions of the world, its preferred habitat being low-lying wooded or bushy terrain interspersed with clearings. These environments provide both shelter from predators and a shady respite during the heat of the day, with more open ground on which the bird can forage during the cooler mornings and evenings.

The birds may become more tame with local people in parts of the range where they are not persecuted. They are often found around the edges of farms and villages, where items such as the seeds of arable crops or food, intended for livestock. can be readily gleaned. Such forms of bold, opportunist

behavior often mirror the lifestyle and feeding habits of modern, free-ranging domestic chickens.

For many, keeping chickens is a rewarding hobby, and some positively enjoy having pet chickens about, and for whom the regular supply of fresh eggs is a pleasant bonus. For such people it is also a natural way of introducing children to animals and their care, and even to teaching them some of the inescapable facts of life.

Some owners may go on to exhibit their chickens in shows, and those interested in this activity may well discover that a new and exciting world is revealed, while those deciding on a chicken or two will find many breeds from which to choose.

Not all chickens make good pets or are easy to keep: some are fragile or require special care and conditions, while others are downright unsociable and may even deliver a sharp peck if approached too closely. But there are many

breeds from which it is possible to chose a perfectly friendly and easy-to-keep bird. A reputable breeder will usually advise the kind best suited to your needs and will suggest the type of conditions in which they should be kept.

Many of the world's chicken breeds are described in the following pages, together with their origins, and some useful advice is offered on providing for their needs. But the more research you can do for yourself, by talking to experts, visiting exhibitions and poultry shows, and by reading many of the excellent books available on all aspects of the subject, the more satisfying the whole experience will prove to be.

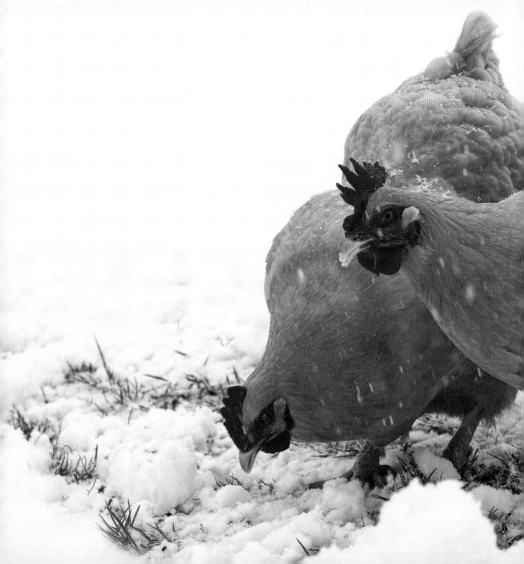

A pair of Buff Orpington hens scavenging in the snow, their plumage taking on a more golden tone in the reflected light.

THE DOMESTICATED CHICKEN

The domestic chicken (*Gallus gallus domesticus*), as we have seen, is closely related to the jungle fowl. Not only are there strong physical similarities between the two, but their habit and way of life are remarkably similar. But let's start at the beginning. The chicken is a warm-blooded, egg-laying vertebrate animal ('vertebrate' means that it has a backbone), and it is placed by zoologists in the class Aves along with all the other types of birds. (The other classes of vertebrates are fish, amphibians, reptiles and mammals.) Within the class Aves the chicken is placed in the order Galliformes (the gamebirds), which encompasses over 180 different species, including many familiar ones such as the pheasants, quails, grouse, turkeys, partridges, guinea fowl, and bobwhites. Different representatives of the order Galliformes are distributed over most of the world, including Europe, Asia, America, and Australia. Within this order, the chicken is further grouped into the biggest family, the Phasianidae, which includes the pheasants.

The chicken is a fairly unremarkable bird by some avian standards, and in that respect could be said to be fairly typical of gamebirds as a whole. The chicken neither flies spectacularly, nor does it have a fascinating or dramatic way of catching its food, it has no ability to mimic, it can't swim, its mating displays only seem to impress other chickens, and it doesn't look especially streamlined or eye-catching.

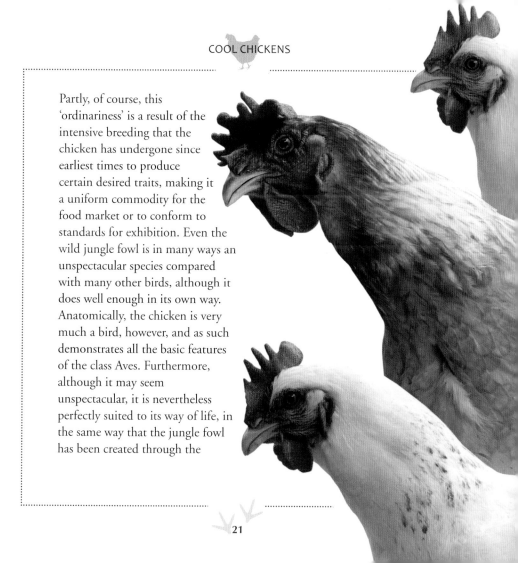

Partly, of course, this 'ordinariness' is a result of the intensive breeding that the chicken has undergone since earliest times to produce certain desired traits, making it a uniform commodity for the food market or to conform to standards for exhibition. Even the wild jungle fowl is in many ways an unspectacular species compared with many other birds, although it does well enough in its own way. Anatomically, the chicken is very much a bird, however, and as such demonstrates all the basic features of the class Aves. Furthermore, although it may seem unspectacular, it is nevertheless perfectly suited to its way of life, in the same way that the jungle fowl has been created through the

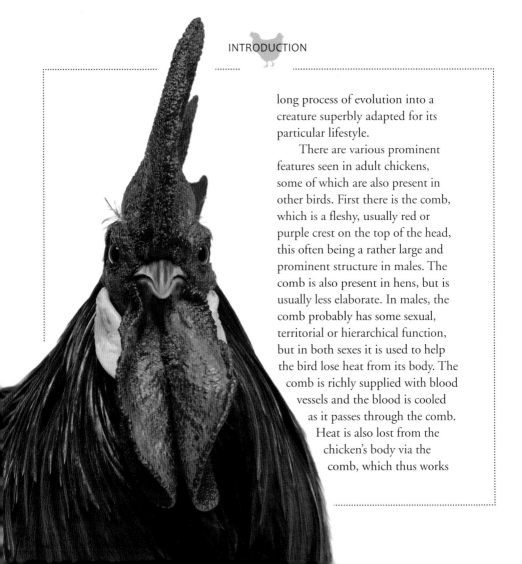

long process of evolution into a creature superbly adapted for its particular lifestyle.

There are various prominent features seen in adult chickens, some of which are also present in other birds. First there is the comb, which is a fleshy, usually red or purple crest on the top of the head, this often being a rather large and prominent structure in males. The comb is also present in hens, but is usually less elaborate. In males, the comb probably has some sexual, territorial or hierarchical function, but in both sexes it is used to help the bird lose heat from its body. The comb is richly supplied with blood vessels and the blood is cooled as it passes through the comb. Heat is also lost from the chicken's body via the comb, which thus works

as a kind of 'radiator.' Combs are delicate structures and of necessity have no protective feathers; in some breeds they can be prone to frostbite in winter.

Chickens have some distinct features which make them instantly recognizable. The comb may be formed into a number of points, or perhaps be V-shaped, the comb varying according to the breed of chicken. The **rose comb** is broad, fleshy and solid, being almost flat on top. Depending on the breed, the comb may turn upward, appear almost horizontal, or trace the contour of the head. The **strawberry comb** is low in profile and set well forward on the head, and resembles the outer surface of a strawberry. The **silkis comb** is round and lumpy, being wider than it is long, and is covered with

indentations and corrugations. The **single comb** is a thin, fleshy structure with a smooth and soft surface, starting at the beak and stretching along the top of the head. The top of the comb has a series of distinct points and corresponding depressions, usually five or six in number, giving it the characteristic appearance often associated with a 'typical' chicken – especially a cockerel or rooster. It is held upright in males, while in females it may be upright or fall to one side according to the breed. The **cushion comb** is low and fairly small with an almost straight front, sides and rear and no spikes. The **buttercup comb** has a cup-shaped crown set in the center of the skull, with prominent points. The **pea comb** is a low comb of medium length, whose top is characterized

by three ridges running lengthwise; the center ridge is slightly higher than the ones at the side, and the outer ridges are either undulated or have small serrations. Finally, the **V-shaped comb** is composed of two horn-like parts joined at their bases.

There are also flaps of red skin that hang down from the sides of the beak. These are called wattles, some of which are quite long and pendulous. Again the size and shape of the wattles vary according to the sex of the chicken and the breed. Like the comb, the function of the wattles is to help the body lose excess heat in hot weather.

A chicken's head is not entirely covered with feathers: there are bare patches of skin on the sides of the head, and on each side there is a specific area called the earlobe. The earlobes may be red or white, and they are a useful feature that help to distinguish certain breeds. As a general rule, chicken breeds that have white earlobes lay white eggs, whereas breeds with dark (red) earlobes tend to lay brown eggs – although this is not a hard and fast rule. For example, the breed of chicken known as the Silkie usually has dark earlobes although the hens invariably lay white eggs.

OPPOSITE: A hen with a cushion comb, this being round, small and solid, with no points or ridges.

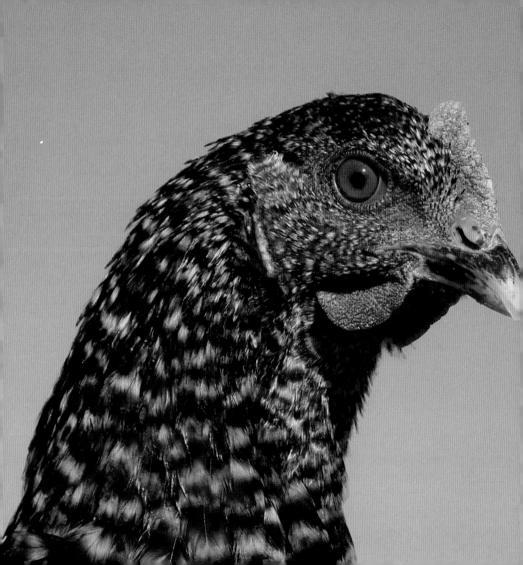

REPRODUCTION AND EGG-LAYING

Chickens usually become sexually mature at about 18 to 24 weeks of age. Free-ranging chickens may show some of the forms of mating behavior seen in their wild jungle fowl cousins: the cock may first call hens to him by finding food items for them, then he may drop one wing, fan his tail, and lean and twist over the female before mating with her and fertilizing her eggs. The eggshell, being a tough, waterproof protective layer made from a type of calcium carbonate called calcite, encompasses the egg, protecting it as it travels down the lower part of the oviduct.

Once the hen lays her eggs – in natural conditions usually in a mere scrape on the ground – she may become broody, making her sit resolutely on her eggs in order to incubate them. She will resist attempts to remove her from her nest, and may even be reluctant to leave it to feed or preen herself. The hen will turn the eggs regularly at this time to ensure they are kept at a constant temperature. Cochins and Cornish hens are

among the broody types, but many modern breeds do not, or abandon the activity part-way through the incubation period. Domestic chickens which are less prone to broodiness are favored by egg-producing farmers, since the hen is ready to lay eggs again more quickly than the broody type.

Chickens become accustomed to laying their eggs in the same place each time. Farmers and other chicken-keepers often put artificial eggs made from stone or other materials in places where they want the chickens to lay. Flocks then tend to use only a few preferred locations instead of each individual bird choosing a different spot. Hens may even try to choose the same nest for their eggs. These are all beneficial behavioral traits as far as the farmer is concerned, since it

means that eggs can be gathered quickly and safely without having to hunt around for them.

During the incubation period the developing chick gets nourishment from the yolk within the egg. Incubation lasts for about 21 days – about the same length of time as in the jungle fowl – and assuming the eggs were fertilized by the rooster, they are then ready to hatch. The eggs are not always laid at the same time, so there is a gap between hatchings during which time the broody hen stays on the nest. When the chicks are ready to hatch they emit cheeping sounds to which the hen responds by gently clucking, encouraging them to cut their way out of their shells using their egg teeth. These are small, sharp, raised parts of the upper bill, which become absorbed after hatching.

BEHAVIOR

As already seen, a free-range or unconfined chicken shares many traits with the jungle fowl. Chickens are gregarious by nature and will form flocks, often of more than one breed. This communal approach to life also extends to the incubation of the eggs and care of the young. A hierarchical dominance exists in flocks, and individual chickens hold sway over others, establishing a pecking order such that the most dominant birds get priority when it comes to accessing food and the best places in which to nest.

Roosters are top of the pecking order, and will attempt to surround themselves with a harem of hens, which they will defend against other males. If dominant roosters or hens are removed from the flock, a new social pecking order will become established in time.

Roosters are associated with crowing, and the shrill, persistnt and penetrating call can be a source of great irritation; in fact, the decision by a neighbor to 'keep chickens' is nearly always viewed with dismay. It is one thing to experience the sound if you have always been accustomed to it, but others find it hard to endure being habitually woken at first light, or even earlier. As mentioned previously, roosters also crow at night and even during the day, the reason for the call being similar to that which causes other birds to make sounds: the rooster is signaling

OVERLEAF: Males are top of the pecking order and will surround themselves with as many hens as possible.

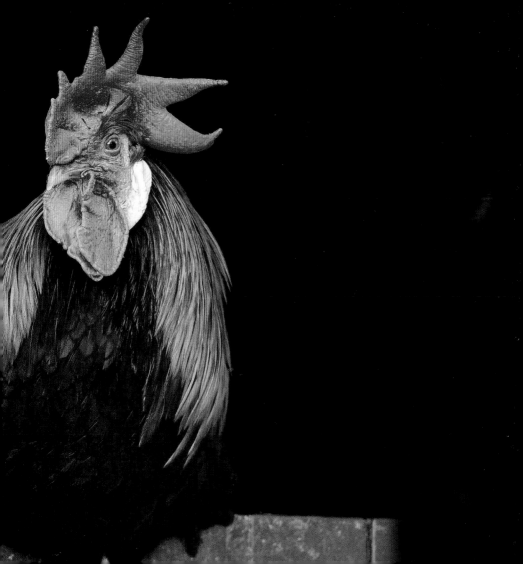

his territorial claims to other males, even though there may be none in the vicinity, while at other times the call is provoked when the bird has been disturbed and is sounding the

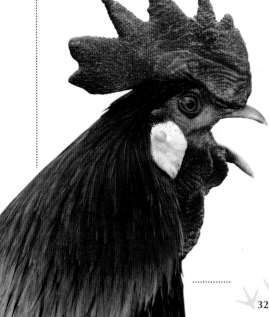

alarm. Hens, in comparison, are reasonably quiet, gently clucking to their chicks. They may become more vociferous after laying eggs, however, but this is mild compared with the strident call of the male.

Parental care consists of the hen occasionally feeding the chicks, although usually she simply leads them to food and water or calls them to edible items she has found. For a while, she will also protect the chicks, taking them under her wing, but will begin to lose interest in them after a few weeks when they will be left to fend for themselves. At this point, the hen may lay again, the cock having played no part in the rearing of the young. The lifespan of a chicken, under natural conditions, is up to about seven

years, although some have been known to live for ten or 15 years or more.

PET CHICKENS

Chickens have been kept as pets for centuries, and choosing the right one for the purpose often yields a surprisingly interesting and friendly companion. As with most other types of living things, some individual chickens are tamer than others, even within a breed which is generally known to be well-disposed toward human beings. And it is certainly true that some breeds make better pets than others. In the descriptions of the breeds of chicken that follow, there is usually some indication of the types generally thought to make good pets.

On the whole, breeds suitable for this purpose are those that are relatively light in weight (large chickens are hard to pick up, especially by children). It is also sensible to choose a fairly hardy type and one that has no fancy or elaborate feathering, especially around the feet, since they are liable to cause problems in some cases if they are neglected. Bantams (usually smaller versions of 'standard' breeds, although sometimes breeds in their own right) can often be a good choice. Avoid male birds, since they can be aggressive by nature. Some chicken breeds live longer than others, and this may also need to be taken into account.

If handled kindly from an early age, chickens can become quite affectionate, and one hen we know

had the habit of coming up and resting her head on her owner's leg, as if asking for her head to be stroked.

Another aspect of keeping chickens is that many highly ornamental varieties now exist, with features such as unusual coloration, feathering, and so on. In the event of choosing such a bird, showing them can be an interesting and rewarding pastime, and visiting exhibitions and shows can open up a whole new field of interest. But remember that some ornamental breeds may be less hardy and require more care to keep them in peak condition than other breeds.

As pets, chickens can be thought of as being reasonably 'low maintenance,' which doesn't mean they should in any way be treated

in a cavalier fashion in terms of their welfare. Some chickens are hardier than others, as already mentioned, but they all need warm, dry, and safe places in which to roost at night, and somewhere where they can shelter from the heat of the sun or from inclement weather during the day. Given suitable conditions and the right food, chickens will thrive, but their health will soon begin to suffer if they are neglected.

One of the greatest hazards facing chickens in a domestic setting is that of predators, and other pet animals, such as cats and dogs, will certainly take their toll given the chance. Wild animals such as foxes, squirrels, raccoons, and other prowling creatures are a real threat, and extremely upsetting though this may be, a fox will do more than kill a single chicken, and is liable to devastate an entire flock once it gets into an enclosure. Once considered more or less nocturnal, foxes of late have become bolder and more opportunist, being commonly seen by day in many places, so keeping chickens securely fenced at all times is good practice, particularly if they are allowed to range free.

SAFE HOUSING FOR CHICKENS

Many types of proprietary chicken housing systems are available, and there are plenty of companies around which can supply the items or even design and erect 'bespoke' housing especially for you. Have a look on the Internet. In appearance, many typical proprietary systems are fairly similar to the type of structure often used for keeping pet

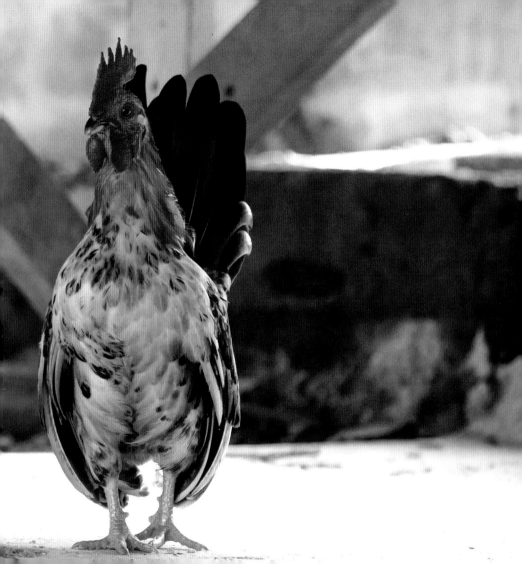

rabbits or guinea pigs outside. They are constructed of a wooden frame, which may be square or rectangular, usually with a side door for access. Other types may be triangular in cross-section, but in all cases the base of the run or pen is open to allow the bird to scratch and forage on the ground. One end of the pen includes the roost, which is a solid structure with a secure door and a waterproof top.

Unless you intend to let your chickens range freely, then an alternative system that works well is to keep them in a large, strongly-made and permanently sited pen – usually made from wire mesh attached to a wooden frame – and to include within it or as part of it a sturdy, solid-sided but well-ventilated roosting place. The outer pen must have sufficiently high sides to prevent the chickens from escaping, and if possible be high enough to discourage cats and other animals from getting in too easily; 5 feet (1.6m) is the minimum for an open-topped run. A safer method is to have a relatively high-sided pen with the top covered with mesh as well, making it completely secure. Such an enclosed system is regularly used by keepers of cagebirds that are housed outside. Sometimes the best solution to prevent marauding foxes is to install electric fencing or electrified netting.

LEFT and OVERLEAF: Chickens are relatively safe roaming freely during the day, but must be well-secured at night.

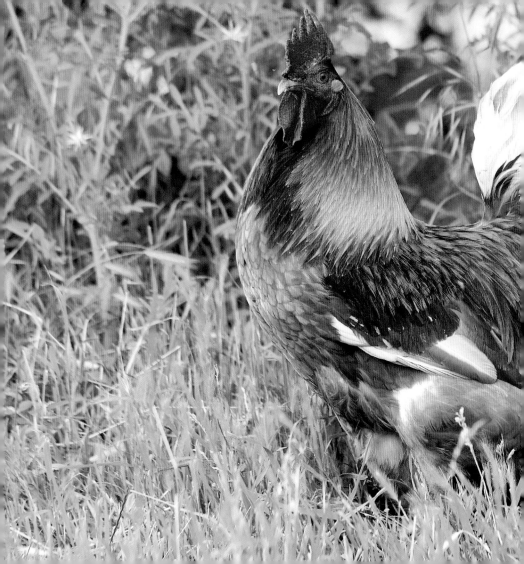

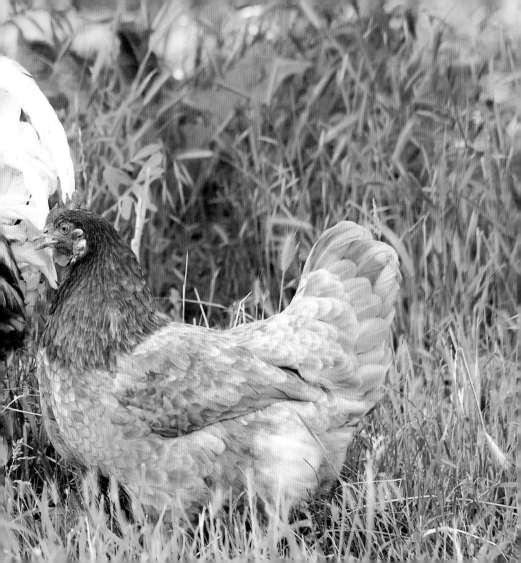

Any pen should obviously be positioned on suitable, well-drained ground. A roughly grassed area, or one that has soil and a few bushes, is ideal: the chickens will soon turn it into a suitable habitat by scratching around in the earth, pecking at the foliage, and generally making themselves at home. Tree stumps or other suitable objects scattered around will give them something that they can fly or hop onto, and will add interest to the environment. Like many birds, chickens like to dust-bathe, which helps to remove lice and other parasites and scours the feathers clean. Therefore, in at least a part of the run there should be an area where the chickens can dig themselves a dust hole. If no such area is available, then a suitable, low container should be provided, filled with a mixture of ashes, dry soil and sand.

Chickens, being birds, have a natural urge to roost off the ground at night for security like others of their kind. Therefore roosting perches should be provided so that your chicken or chickens can rest snugly off the floor. Perches should be about 2 inches (5cm) wide for standard breeds but a little narrower for smaller birds. Allow 10 inches (25cm) across for the bird, and the same amount of space between roosting poles if you have more than one chicken. If you do install several perches, it is best to have them graded slightly in terms of level, so that the birds do not all roost at exactly the same height. An inch or two is sufficient; don't set them so high that the birds have difficulty getting up to them. Roosting

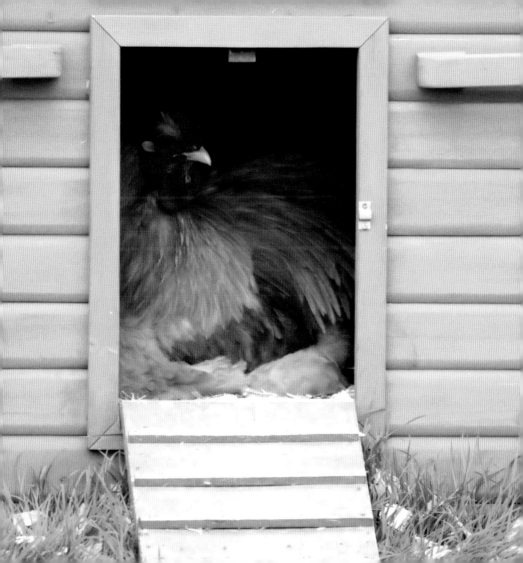

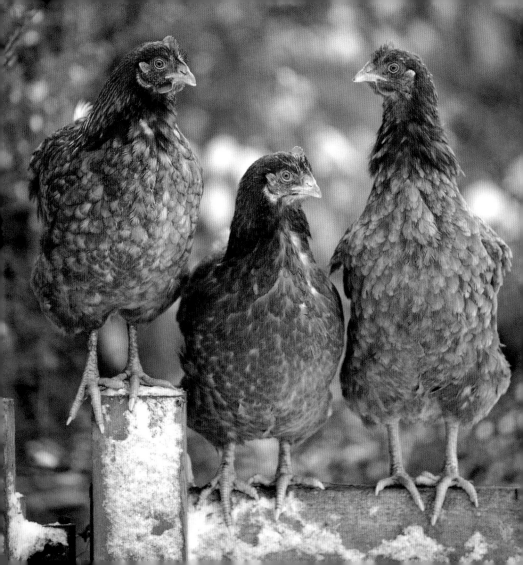

perches should be constructed of timber that has had its bark removed, as cracks and spaces left by fragmenting bark may harbor undesirable or harmful insects.

Chickens have a natural instinct to perch in high-up places which makes them feel safer and more secure.

FOOD AND WATER

Fresh drinking water must be available at all times when the chickens are in the pen. Under normal circumstances it is not necessary to provide water for them in the coop or roost as long as the birds are let out into the pen each morning to access drinking water for themselves.

The wild relatives of the domestic chicken enjoy a varied diet,

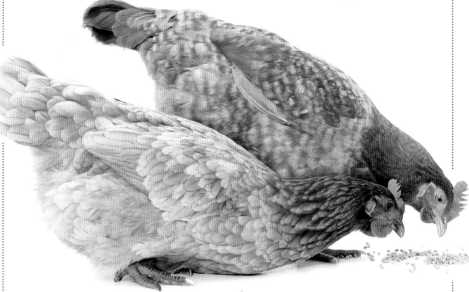

ranging from seeds and other vegetation to insects and even small lizards.

Domestic chickens are also omnivorous in their eating habits, and have even been known to catch and devour the odd mouse that gets into the enclosure! But for those beginning to keep chickens, it is advisable to base the feeding regime around one of the good-quality proprietary complete pellet feeds that are available; this will ensure that they get a balanced diet of carbohydrates, fat and protein, vitamins and minerals (such as calcium needed for eggshells). Use a commercially supplied dispenser or hopper for the pellets to stop them getting wet. A little grain can also be added, such as wheat or corn, to augment the diet if preferred, which can be scattered around the pen area; most authorities advise this should be offered in the afternoon, with the pellet food being given in the morning.

Grit is essential for many birds, not only chickens. Because they are without teeth, the abrasive properties of grit are needed in their crops (part of the digestive system) to help them grind up their food. Some grit should be present in good-quality proprietary feed, but it is worth providing a small container with an extra supply so that the chickens can take as much as they need.

Chickens also appreciate a little fresh greenery, so let them get on to grass as often as is possible, or offer them plants to eat such as chickweed. Chickens are also happy to eat leftovers from the

kitchen, but not of course as a substitute for properly designed chicken feed. They will eat fruit, cabbage, vegetable peelings, and so on. Do not, however, offer them anything strong-tasting such as onion, garlic, or spices; neither should they be given citrus fruits (such as oranges and lemons) nor any food in the process of 'going off'; chickens shouldn't eat rotten food any more than we should ourselves; moreover, the likelihood is that it will be rejected and will be left to rot still further, eventually attracting vermin and flies.

LAYING EGGS

Even if you are keeping a single hen as a pet, she will reward you with eggs if you encourage her to lay. A nest box should be provided, raised a few inches off the ground within the roost; it should be lower than the highest roosting pole, however. Position the nest box in a quiet, dark place to help her feel more secure. Again, there is plenty of advice available in books and on the Internet about creating the ideal conditions for successful egg-laying. For example, it is possible to buy dummy eggs made from stone that encourage first layers to sit on their eggs without crushing

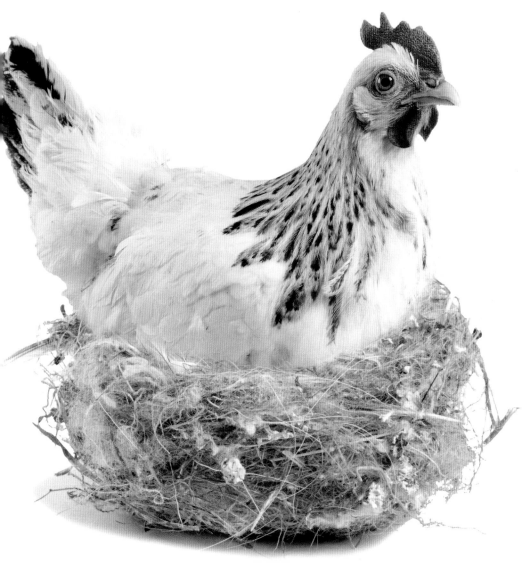

them. When I was young I used to have great fun dropping these eggs in front of people who didn't realize they were not real, just to see the expression on their faces! The bottom of the nest should be lined with a little clean straw or pinewood shavings to help prevent the eggs from breaking when they are laid. (Despite all these measures, you will inevitably find broken eggs in the roost from time to time.) Contrary to popular belief, a chicken will still lay eggs whether a rooster is present or not. The only difference is that without a cockerel around to fertilize them they will never produce chicks.

OBTAINING A CHICKEN

Once all the necessary accommodation and equipment is in place you can begin to think about obtaining a bird and introducing it to its new home. At this point it is more than likely that you have reached a decision concerning the type of chicken you want and why you want it; in other words, is the chicken essentially for eggs, will it eventually be for eating, will it be for showing, or will it simply be kept as a pet? To help you make up your mind, the breed descriptions in the next section will provide much information about different types of chickens, such as size and color

A Silkie hen and her chicks. Silkies are calm, gentle birds that prefer to be with their own kind, making them unsuitable for mixed flocks.

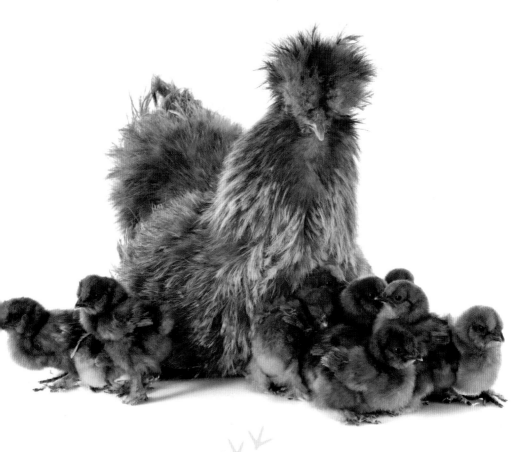

and their temperament and hardiness. Remember that the more you can find out beforehand about your potential purchase from other sources, including breeders and the Internet, the better. Seeing the actual breed in the flesh, moreover, is the best way of ensuring you will be ultimately satisfied with your choice.

If you wish to keep chickens primarily for the quality of their eggs, then a commercial hybrid is the best choice. If you would prefer the eggs to be a particular color, then go for a pure breed. Wyandottes and Rhode Island Reds, for example, are among the breeds that lay mid-brown eggs, Leghorns are among those that lay white eggs, while Sussex hens lay tinted eggs. Welsummers and Barnevelders lay dark-brown eggs,

and Araucanas lay blue eggs. One of the drawbacks with hybrids is that they do not have the distinctive look of some of the more spectacular breeds, but in their favor is the fact that they are cheaper to buy, come vaccinated against disease, and are excellent layers, some producing well in excess of 300 eggs in a year. Hybrids, of course, are the mainstay of the commercial industry for both meat and eggs.

Most breeds have their own clubs, whose members can put you in touch with reputable local breeders in your area who can sell you a pullet (a young hen under a year old). It is always best to visit the premises of the breeder from which you intend to buy, so that you can assess the conditions under

which the birds have been raised. Talk to the breeder and explain your reasons for wanting the breed you have chosen and try to obtain as much information as you can about it – how to care for it, any special traits it may have, and so on. Becoming a member of the breed club for the chicken you have chosen is a good way of obtaining more information. Another way, before you make a purchase, is to visit a poultry show or an event such as a country fair, where various breeds can be viewed.

Another route is to buy fertilized eggs and place them in an incubator until they hatch. This is particularly exciting for children, and there is the added benefit of seeing the chick at the very earliest stages of its life. If you are planning to try this, you must ensure that all the necessary equipment is in place before you obtain the eggs. There are plenty of books and websites that tell you how to set up an incubator, what the correct temperature should be, and what to do once the chicks have hatched (for example, they need to be fed on chick starter feed for about six weeks, followed by a pullet feed). It is likely that most sources of information will also warn you to make sure that the chicks are kept safe from another form of predator – in this case the pet cat or dog, which may be tempted to eat a small chick found sitting in a warm box in the house!

Ex-battery hens, which have reached the end of their commercial lives – usually at about 72 weeks – are fast becoming

another choice for the amateur chicken-keeper or for those who want a bird or a number of birds that they can keep on a small scale. There are several organizations that specialize in rescuing these hens and offering them to people willing to give them a new life. It can be an initially sad yet ultimately rewarding experience to take on one of these birds. Some of them will be traumatized and even in poor condition to begin with, having poor feathering and may even need to regrow their beaks. But just as with other rescue animals, such as cats and dogs, with the proper care and attention there is no reason why they should not in time return to their full vigor and fine appearance.

HOW TO HANDLE A CHICKEN

Like most animals, there is a right and a wrong way to pick up a chicken, for one that is dropped or mishandled, though unintentionally, is likely to become wary and apprehensive even of being stroked, and won't make a good pet as a result. For this reason, it is advisable that young children are taught the correct way to handle a chicken right from the start. Remember that large breeds don't always make good pets; the urge to pick up and cuddle is enormously strong in children, but large animals don't fit into small arms!

Before you pick up a chicken, it is often useful to let it get to know you first. Try offering a few tasty morsels, or approach very slowly and attempt to touch or stroke the bird.

To pick up a chicken, place your dominant hand (the one you write with) on the middle of its back. Use the thumb and forefinger of that hand to gently but firmly secure the wings so that they can't flap. Now, using your other hand, enclose one of the chicken's legs with your thumb and forefinger, and the other with the forefinger and middle finger of the same hand. Now lift the chicken up, using the heel of your hand and your wrist to support the underside, keeping your dominant hand on the chicken's back in the meantime. Now you can hold the chicken close to your body to prevent it from wriggling; it's best to sit down with the chicken at this point. After a time, the chicken will come to realize that this activity on your part results in its movements being

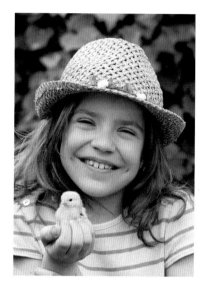

somewhat curtailed, and as time goes on it should cease to struggle. Soon you should be able to pick it up without any fuss, especially if you talk to the bird gently and stroke it while it is in your arms.

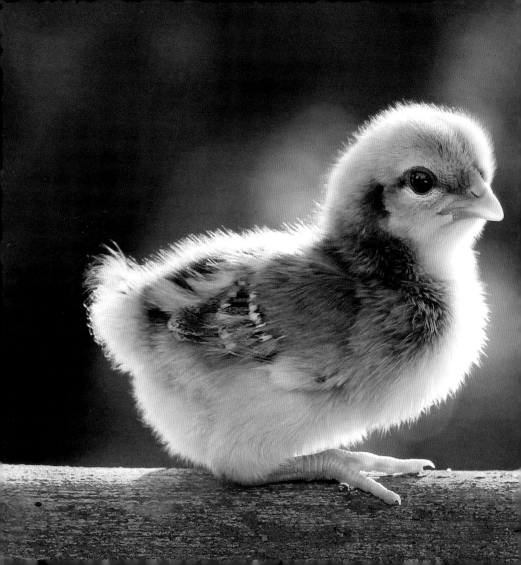

CHICKEN
BREEDS

CHICKEN BREEDS

Today there are over 70 breeds of chicken, and many of them come in a range of varieties, including smaller bantam forms. The physical traits used to distinguish breeds are size, plumage color, comb type, skin color, number of toes, amount of feathering, earlobe color, egg-color, and place of origin. There follow descriptions of many of these breeds and their varieties.

AMERAUCANA

The Ameraucana originated in the United States when it was first developed in the 1970s from Araucana chickens brought from Chile. Once established as a breed, it retained the unusual blue-egg gene of the Araucana and was added to the Standard of Perfection of the American Poultry Association in 1984. As the name suggests, the name Ameraucana derives from 'America' and 'Araucana.'

The Ameraucana is a notable breed, for it is one of the few chickens that lay blue eggs. Although it shares many similarites with the Araucana, it is tailed, muffed, and bearded, whereas the Araucana in the USA has earmuffs and is rumpless. The earlobes are small and round, the wattles small or absent; earlobes, comb and wattles are all red. The shanks are slate-blue, tending to black in the black variety. Recognized colors are: black, blue, wheaten, brown-red, buff, silver, wheaten, and white.

'I want there to be no peasant in my kingdom so poor that he cannot have a chicken in his pot every Sunday.' - Henry IV of France

ANTWERP BELGIAN BANTAM

This ornamental bantam, otherwise known as the Barbu d'Anvers in France and Antwerpse Baardkriel in the Netherlands, is a breed of true bantam (in that it has no full-size counterpart) originating in northern Flanders, Belgium. In the USA it is known as the Antwerp Belgian or the Belgian d'Anvers. Fortunately, its popularity has ensured that it is one of the few bantam breeds not threatened with extinction. It is kept as an ornamental breed, either as a pet or by poultry fanciers for showing or exhibition. The hens of the breed make good companions where human beings are concerned and are agreeable pets, even though the males may be less friendly or even aggressive.

Most Antwerp Belgians live longer and more healthily if kept in a free-ranging environment where there is no overcrowding. Common colors are black, mottled, porcelain, and self blue, although many other colors are also recognized. The Antwerp Belgian is small, compact and proud and the male in particular is known for its well-developed neck hackle. The hens are known to be good mothers.

APPENZELLER

The Appenzeller is a Swiss breed, known for hundreds of years and named after the region in Switzerland where it was developed. It comes in two versions: the Barthuhner and the Spitzhauben, the Barthuhner being the more robust-looking of the two. The Barthuhner is also bearded and has white earlobes; it has a rose comb rather than a crest on its head.

Appenzellers have tight plumage, strikingly marked, and widespread, upright tails. The eyes are dark brown. Silver-spangled Spitzhauben varieties have silver-white feathers with black, while in the gold-spangled varieties the ground color is golden-red. On the head the unique crest is forward-facing – said to resemble the traditional bonnets worn by women in the Appenzellerland region – and there is also a split, horn-type comb. The wattles are long and fine and the beak is relatively large and powerful. The legs are devoid of feathering and blue-gray in color. As well as the silver-spangled and gold-spangled varieties, there is also a black variety.

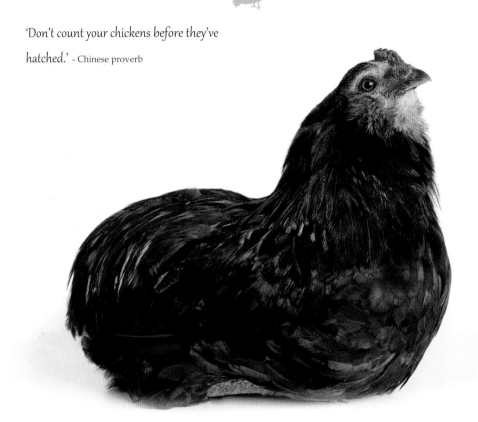

'Don't count your chickens before they've
hatched.' - Chinese proverb

ARAUCANA

The very distinctive Araucana chicken originated in South America, named after the Arauca Indians of Chile and first mentioned in documentation dating from around the mid-16th century. It was introduced to Europe in the early 1900s, and the breed standard was set at a meeting of the Rare Breeds Society in 1969.

The bird has no wattles. The feathers on the face are very thick, and there is a small crest on top of the head. There is an unusual wart-like feature on either side of the head where in other breeds earlobes are usually seen. The birds are deep in the body with an upright stance and with a fairly long back reminiscent of the Asiatic game type. They may be born with or without a tail; those without a tail are known as rumpless Araucanas.

Another distinctive feature is the bird's blue-green egg, the color of which extends all the way through the shell. Hens tend to lay during the spring and summer months only, generally becoming broody and making good mothers. Araucana chicks are strong, fast-growing, and quick to mature.

The Araucana comes in blue, black, cuckoo, lavender, gold duckwing, black-red, white, and spangled.

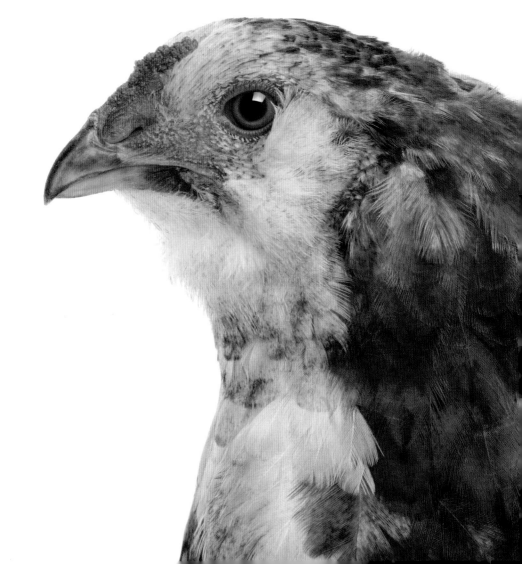

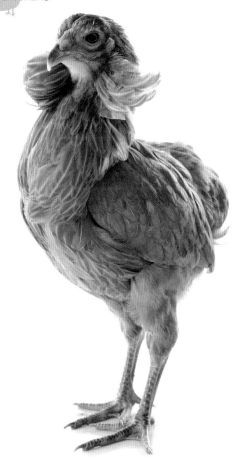

'The chickens have come home to roost.'

American expression

LEFT, RIGHT and OVERLEAF: Araucana
chickens at various stages of development.

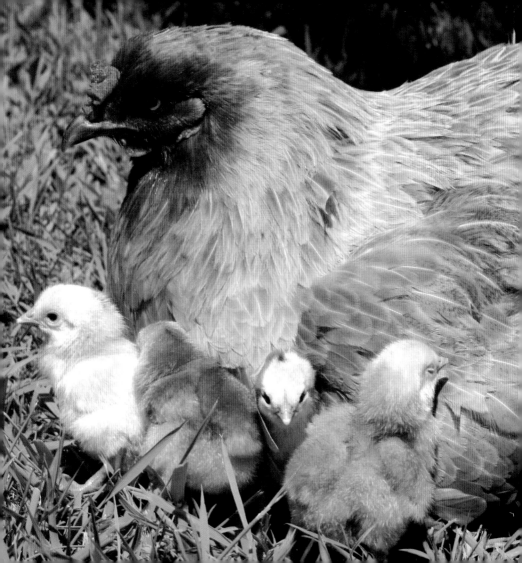

AUSTRALORP

The Australorp is an Australian breed developed from Black Orpington stock that was imported into Australia from England in the 1890s and early 1900s. Here, the imported stock was crossed by local farmers with breeds such as White Leghorns, Minorcas, and Langshans to improve the general quality of the Orpingtons. The original birds were called Black Utility Orpingtons, the name 'Australorp' having been adopted by a poultry fancy institution before the First World War. In 1929 the Australorp achieved Standard of Perfection status.

Hardy and docile, the Australorp is smaller and neater than the Orpington from which it derived, although it is still a substantial bird, and its soft black feathers have an almost metallic-green sheen. The eyes and legs are dark, and the combs, cheek patches, and wattles are red; the comb has five distinct upright points. The Australorp isn't a good flier, even though it is quite active and likes to range free. Although it is one of the best of the dual-purpose chickens, the breed's egg-laying abilities first brought it to the attention of the international community when, in 1922–23, six hens set a world record by laying 1,857 eggs at an average of just over 309 eggs per hen over a 365-day consecutive period.

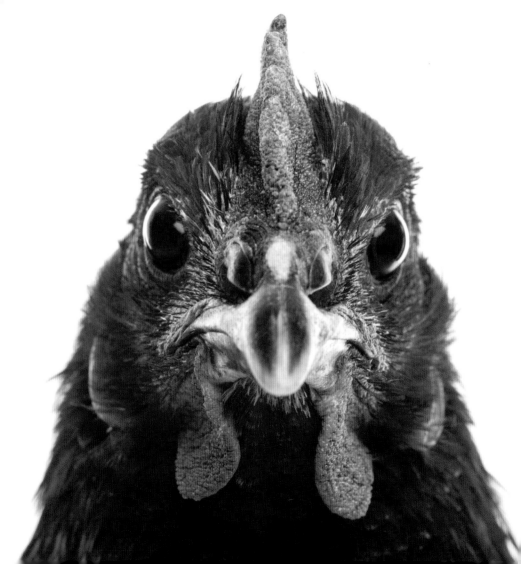

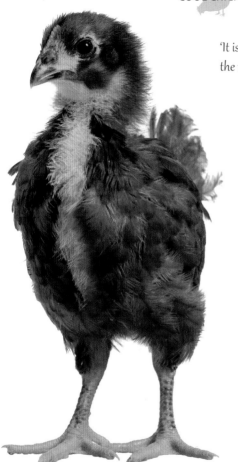

'It is better to be the head of a chicken than the rear end of an ox.' - Japanese proverb

LEFT, OPPOSITE and OVERLEAF: The Australorp has soft black feathers shot with an attractive metallic green.

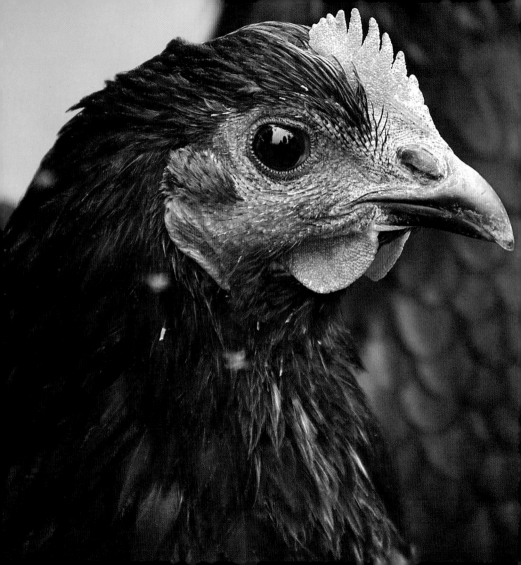

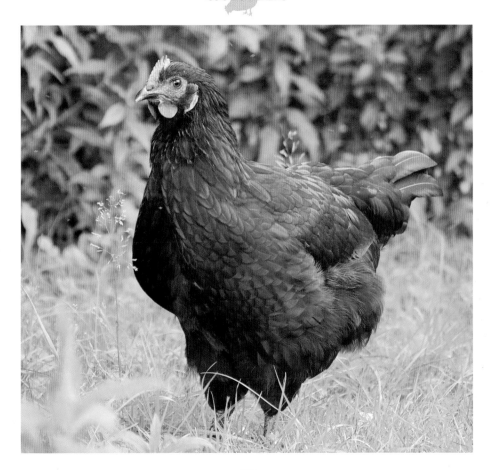

AYAM CEMANI

The Ayam Cemani is a relatively rare breed of chicken that first appeared in the village of Cemani on the island of Java, Indonesia. Despite its humble beginnings in the jungles of Java, the all-black Ayam Cemani is highly sought after in Indonesia and is an expensive bird to purchase. It was believed to possess mystical powers and was for centuries used in religious rites and ceremonies; broth made from this chicken is widely thought to possess special medicinal properties.

The breed was first described in the 1920s by Dutch colonists who imported the first breeding stocks to Europe soon afterwards.

The Ayam Cemani is distinguished by its completely black plumage, legs, toe nails, beak, tongue, comb, and wattle, and its blood, despite being red, is of a darker shade, caused by a genetic condition known as fibromelanosis which can be found in some other black fowl breeds, which is possibly why the hens lay cream-colored eggs tinged with a slight hint of pink.

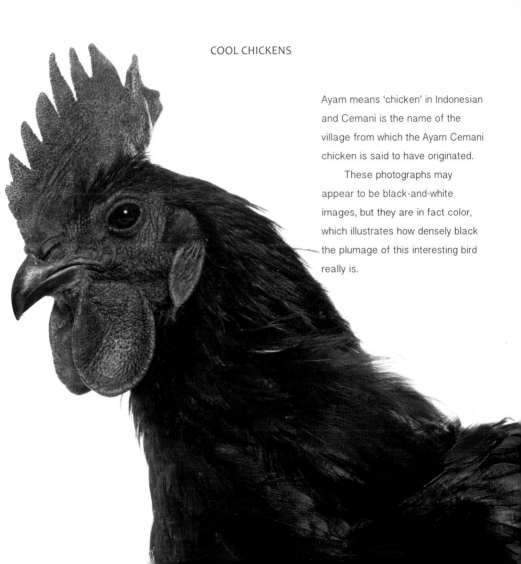

COOL CHICKENS

Ayam means 'chicken' in Indonesian and Cemani is the name of the village from which the Ayam Cemani chicken is said to have originated.

These photographs may appear to be black-and-white images, but they are in fact color, which illustrates how densely black the plumage of this interesting bird really is.

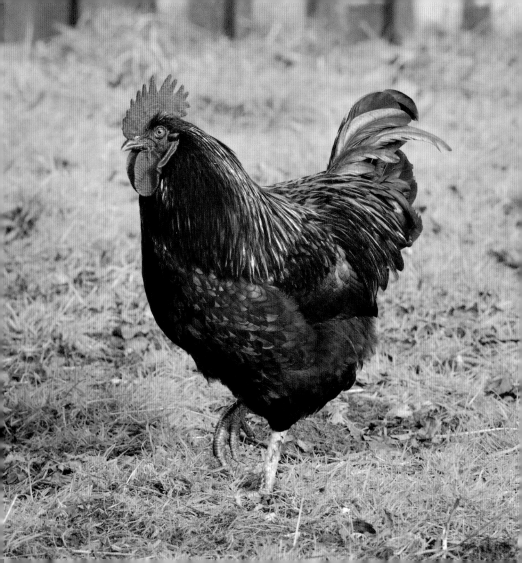

BARNEVELDER

This is a fairly common breed of chicken whose name derives from the Dutch town of Barneveld. It is a hardy bird, bred to thrive in the damp, windy conditions which often prevail in the Netherlands, where the Barnevelder is one of the most popular breeds.

The Barnevelder was created by selective breeding during the second half of the 1800s, when Asian breeds, such as Cochins, Brahmas, Malays, and Croad Langshans were crossed with local Dutch chickens. One of the resulting crosses was bred with Brahmas, and the resulting offspring were crossed with Langshans. Then, toward the end of the 18th century, some American stock was introduced and Buff Orpington from Britain had also been introduced by 1906, so that by 1910 the breed was producing a uniform color and type that was established as the Barnevelder.

A medium-sized breed, the male has a prominent red comb which extends from the base of the beak to the back of the head, and a longish red wattle.

BRAEKEL

The Braekel or Brakel is one of the oldest of the European chicken breeds and shares a common ancestry with the Campine. Its history dates back to 1416, when it was described as a successful poultry breed of Nederbraekel in the Flanders region of Belgium. There is a bantam version of the Braekel.

Two distinct types of Braekel were recognized in the past: the large type, living on the rich clay soil of Flanders, and a light-weight type from the less fertile region of the Kempen. Due to crossbreeding between the different types, however, this distinction eventually vanished, resulting in a single type.

The Braekel population declined during and after the Second World War and it is now recognized as a rare breed.

A straight banding pattern of the feathers, and a uniform solid neck color are characteristic of the Braekel. Several color variants exist, with the gold and the silver variant being the most common.

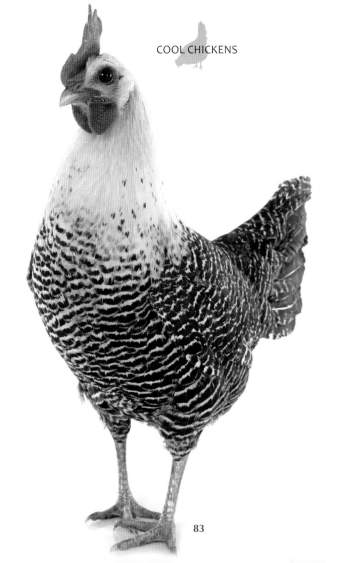

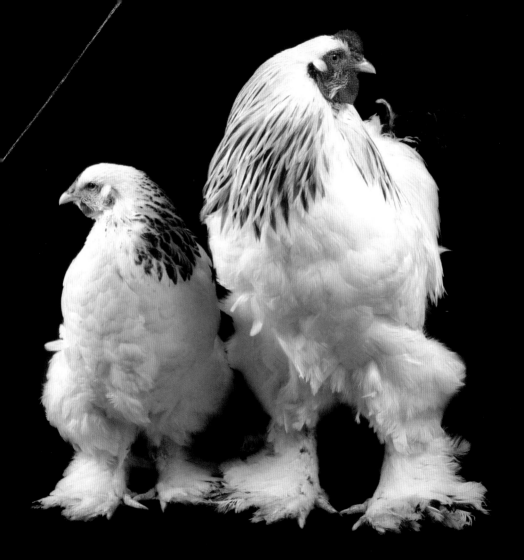

BRAHMA

The name Brahma is derived from the Brahmaputra river in India, yet the breed was actually created in the United States from birds with well-feathered legs, known as Shanghais, imported from China. Development of the breed took place in America between 1850 and 1890. Brahmas grow and mature slowly, taking about two years to reach full maturity, so do not find great favor with commercial farmers. The commanding appearance of the Brahma, however, together with the striking plumage, makes them popular for shows and by fanciers. Brahmas are also elegant, stately, and dignified birds, and their gentle nature and large size, together with the intricate plumage patterning, make them particularly attractive as ornamental fowl.

Brahmas have broad, deep bodies, full long, powerful orange or yellow legs and feet covered in an abundance of soft feathers, giving them the appearance of having large, soft feet.

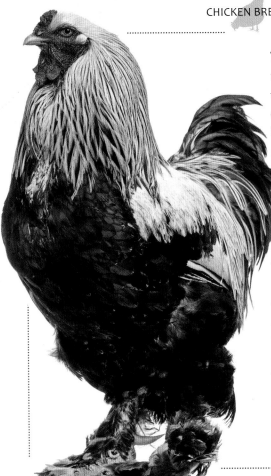

The profuse feathering also stands the breed in good stead in cold weather, although the head seems disproportionately small for such a big bird, the face being smooth and free from feathers. The eyes are large and prominent, and the beak is short and strong. There is either a small red triple comb or a pea comb, and small red wattles, features which again help the breed withstand cold weather.

Brahmas do not fly, and can be confined behind fencing about 2- or 3-feet (0.6–0.9m) high, although their large size means that quite a lot of space is required for them to roam. The profuse feathering on the legs and feet means that dry conditions suit the bird best; the feathers can soon become clogged in wet conditions.

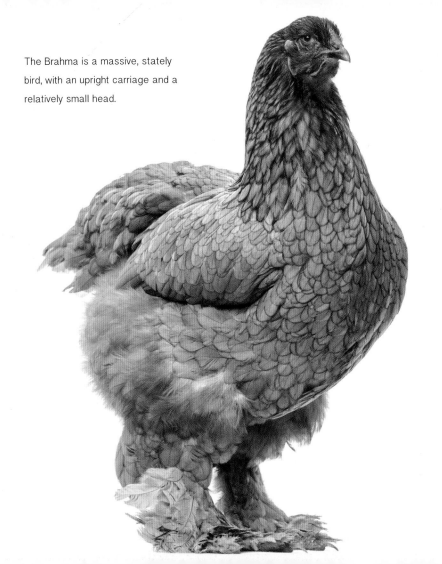

The Brahma is a massive, stately bird, with an upright carriage and a relatively small head.

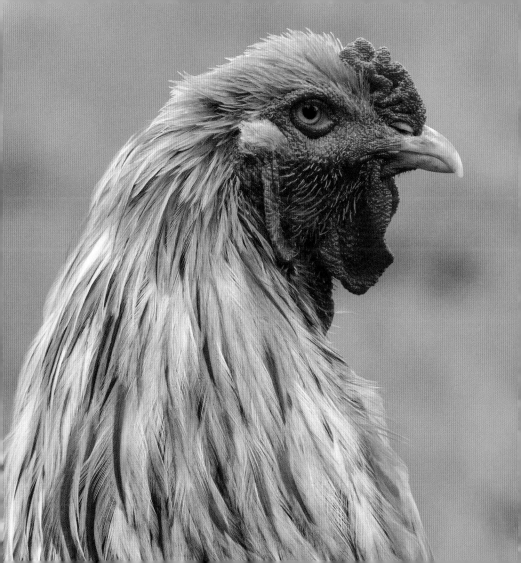

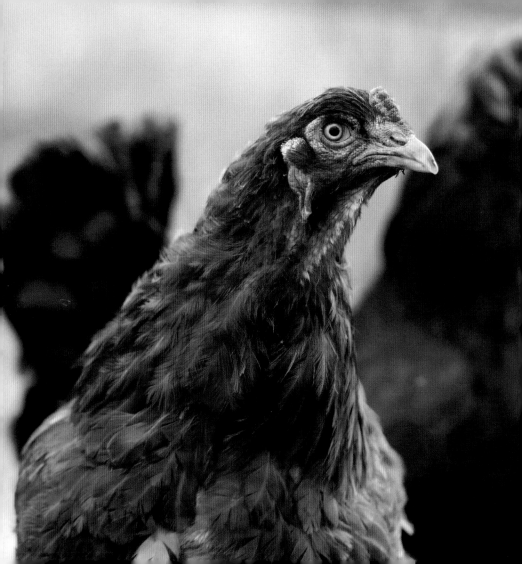

BUCKEYE

Created in the 19th century in Ohio by Nettie Metcalf who, interestingly, is the only woman known to have developed a chicken breed in the USA, the Buckeye chicken was named for Ohio's nickname, the 'Buckeye State'. Furthermore, the Buckeye's color is said to resemble the mahogany color of the seeds of the Buckeye plant (*Aesculus glabra*). The breed was created by crossbreeding Barred Plymouth Rocks, Buff Cochins, and some Black Breasted Red Games. The resulting Buckeye was a functional breed that could withstand the harsh Midwest winters.

The Buckeye is a dual-purpose chicken with good laying ability and is also good for meat production. The breed's primary color is mahogany red, but often has a darker tail and dark feathering in general. It is the only American breed to have a pea comb. The Buckeye is generally a calm bird, but, as with many breeds, the males can be aggressive at times. The Buckeye is sturdily built and hardy. The hens lay brown eggs.

CAMPINE

The Campine originated in the Campine region of Belgium several centuries ago, where it was much prized for its white-shelled eggs. It is thought to have been derived from another, slightly larger, Belgian breed, the Braekel, which is itself one of Europe's oldest breeds, dating from the 1400s. The Campine was introduced to Britain in the 19th century, but has never been especially popular in the USA. This is a fairly small, attractive breed with close, barred feathering. Males are easily distinguished by their longer tail feathers, more showy neck feathers, and their larger combs. The combs can be prone to frostbite, and the birds themselves are not especially hardy, so adequate protection at night or in cold, frosty weather is required.

Campines have lively temperaments and prefer to be free-ranging, although they will adapt to being kept in more confined conditions. They are also inquisitive and alert and will take to the air readily. Not all individuals become tame. They are kept mainly for their ornamental value, favored for their plumage and upright stance, although they produce a good number of medium-sized eggs given the right conditions. They are a non-broody breed.

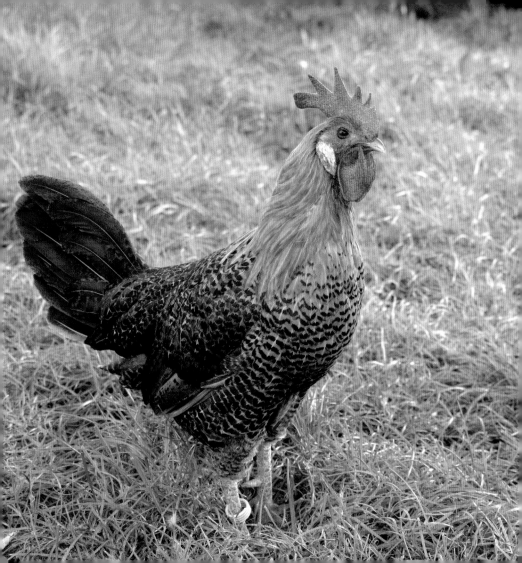

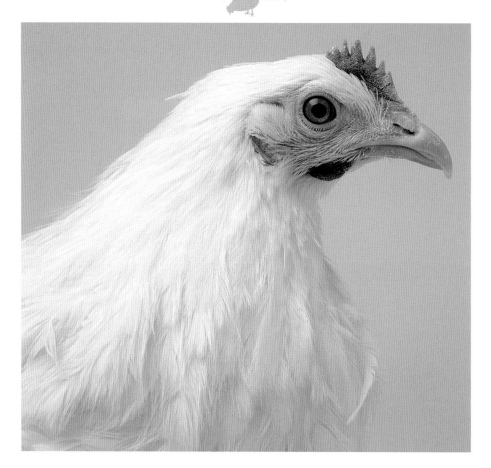

CHANTECLER

The Chantecler is a Canadian breed originating in the province of Québec. It was created to produce a chicken with good dual-purpose qualities, but also one which would be able to withstand the harsh Canadian climate. Thus, for example, the Chantecler has a small comb and wattles to help reduce the effects of frostbite on these exposed parts of the body. The breed came about as the result of two crosses: in about 1908 a male Cornish was mated with a female Leghorn, and a male Rhode Island Red was crossed with a female Wyandotte. Later, females from the first crossing were then mated with males from the second. The Oka Agricultural Institute in Québec first exhibited the breed, and it was given breed status in 1921. A second type, the partridge variety, achieved breed status in 1935.

The Chantecler has a slightly elongated body with a deep, well-rounded chest and with the tail held at about 30 degrees above the horizontal. The head is broad and short, the face is red, with reddish-brown eyes, and the comb and wattles are both small. The earlobes are oval and off-white in color. The short beak is yellow in the white variety, but horn-colored in the partridge variety. Plumage is profuse on the neck where it rests on the shoulders.

COCHIN

The Cochin came to the West from China in the early 1850s, and among the first to receive the bird was Queen Victoria, her interest in the breed leading to its great popularity at a time when no similar type of chicken had been seen. The Cochin is thought to have been bred by the Chinese for its feathers, used particularly to fill bed coverings. It is mainly bred as an ornamental fowl, although the hens make good foster mothers, and are therefore useful for rearing gamebird chicks that have been orphaned or abandoned.

The Cochin looks like a big, fluffy ball of feathers and is very rounded in appearance. It is one the largest of the heavy breeds. It is also broad in stature, which is accentuated by the huge number of

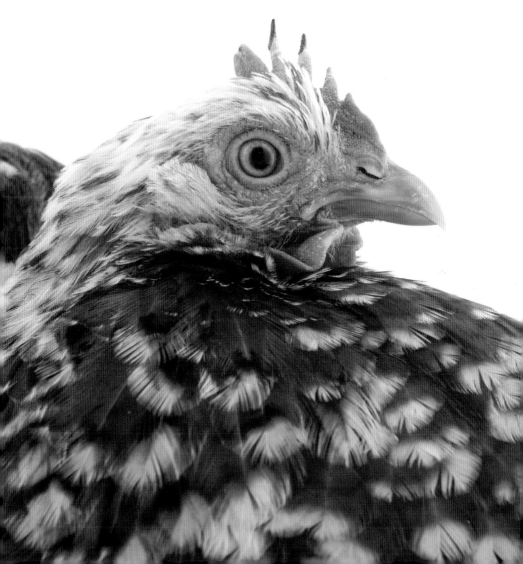

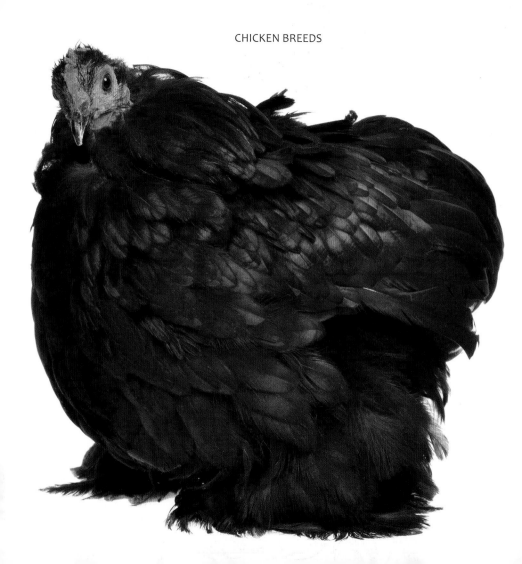

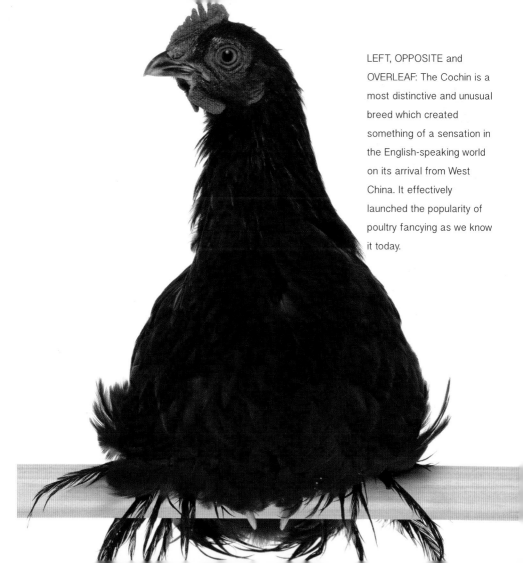

LEFT, OPPOSITE and OVERLEAF: The Cochin is a most distinctive and unusual breed which created something of a sensation in the English-speaking world on its arrival from West China. It effectively launched the popularity of poultry fancying as we know it today.

soft feathers on the body. The comb and wattles are red, and are bigger in the male, while the earlobes are also red. The legs are yellow.

Unfortunately, Cochins are subject to metabolic and cardiac problems – caused partly by their round body shape and somewhat sedentary lifestyles. It is best to keep them on short grass, since longer vegetation can damage the feet and feathers. Wet conditions are also to be avoided, since the feathers of the legs and feet may suffer and mud balls can form on the soles of the feet. The birds can be kept in fairly confined spaces and do not fly, so a fence about 2 feet (0.6-m) high should be sufficient to retain them. Cochin hens are excellent brooders with calm, maternal

instincts. Eggs are large, although not produced in great numbers, and the chicks are strong when hatched. They mature within two years and survive until about the age of eight or ten. Cochins are docile and friendly, and being submissive can be successfully kept with other chickens, attributes which also make them good pets. They need good-quality feed to stay in top condition. Several accepted varieties are available, such as black, blue, buff, cuckoo, white, and partridge.

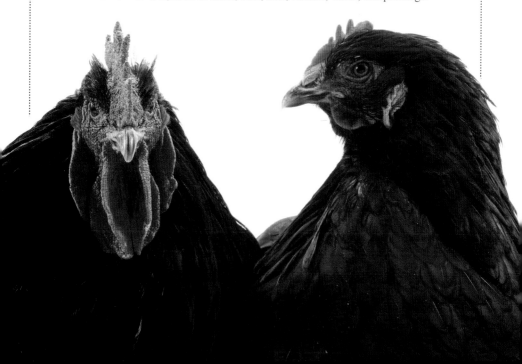

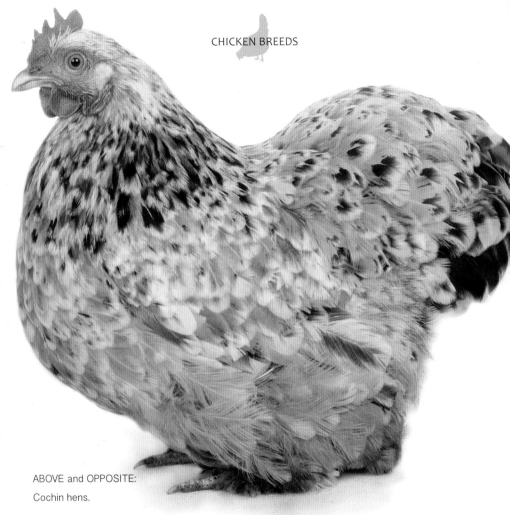

ABOVE and OPPOSITE:

Cochin hens.

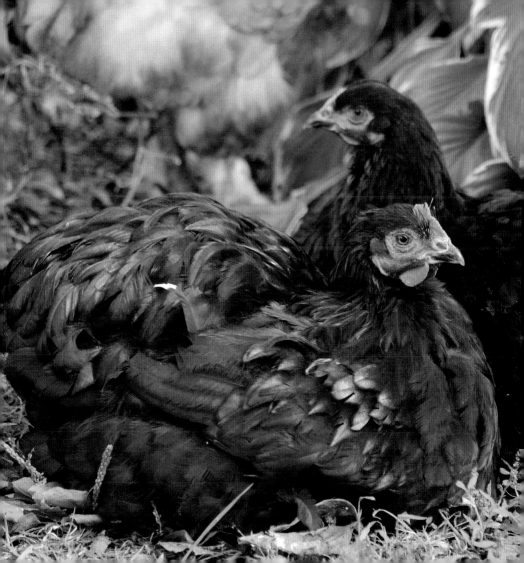

CORNISH

The Cornish, first known as the Indian Game, is a breed of chicken that originated in the county of Cornwall in the United Kingdom. It was first developed around 1820 by Sir Walter Raleigh Gilbert, who bred them from Malay and other oriental breeds. The Cornish is a large, sturdy breed that is often crossed with other breeds to enhance meat production. They are usually wheaten in color, with light brown patterning, but come in many other colors too.

The Cornish is sometimes referred to as the bulldog among chickens, due to its size and stature and the fact that it has very wide-apart legs and a large chest. It has very short and close-fitting feathers, so needs good shelter and a draft-free environment in order to thrive.

The large, deep-set eyes and projecting brow give the Cornish a rather undeservedly aggressive expression, even though the males can be bad-tempered on occasions. Although they are large and heavy, hens are relatively easy to handle and make good mothers.

CRÈVECŒUR

The Crèvecœur is an unusual and very old breed of chicken originating in France. It was first documented in the 1700s, named after the town of Crèvecœur in Normandy. It is believed to have been developed from the Polish due to the feathering on its head.

In France, the breed was originally used for both meat and egg production, although these days, in North America and the United Kingdom, it is generally kept for ornamental and exhibition purposes and has now been designated a rare breed.

The unique and interesting Crèvecœur has uniform black plumage, a 'V'-shaped comb, and a large crest. The legs are dark blue-gray in color. Crèvecœur chickens, which are not particulary docile, require plenty of exercise, although they can tolerate some level of confinement. The breed is reputed to be somewhat aloof although the hens are good layers of medium-sized white eggs.

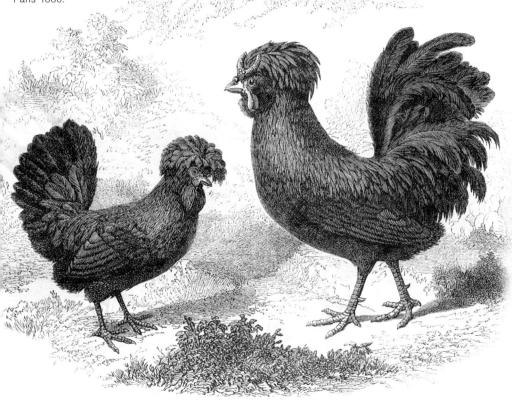

A vintage engraved illustration published in *Magasin Pittoresque* in Paris 1880.

DOMINIQUE

The Dominique is considered to be America's oldest chicken breed. It was first developed from stock that gave rise to southern English breeds, such as the Sussex and the Dorking, and which was brought to New England during the time of the first colonists. The breed had grown in popularity by the 19th century, and was soon to be found in many parts of the USA. The breed's popularity, however, then declined steadily – mainly because the Plymouth Rock breed, derived from the Dominique, found favor instead – and by the 1950s it was almost at the point of extinction; the American Livestock Breeds Conservancy listed it as Critical in the 1970s. But an upsurge of interest in rare breeds helped to revive the Dominique's fortunes, and today its status seems more secure.

Dominiques are a dual-purpose breed, prized both for their meat and for their brown eggs. At one time their feathers were much sought after as a stuffing material for pillows and mattresses. The birds have a distinctive, handsome appearance, with rose combs and a

thick plumage of barred or irregularly-striped black-and-white feathers. This pattern is also called 'hawk coloring,' and apart from providing good insulation for the birds, also helps conceal them from predators.

The breed is quick to mature, and eggs are produced at about six months of age. Dominiques are calm and steady birds – traits which make them good show birds and pets. The hens make excellent mothers and lay light or dark-brown eggs. They also show a lesser tendency towards broodiness than some other exhibition breeds.

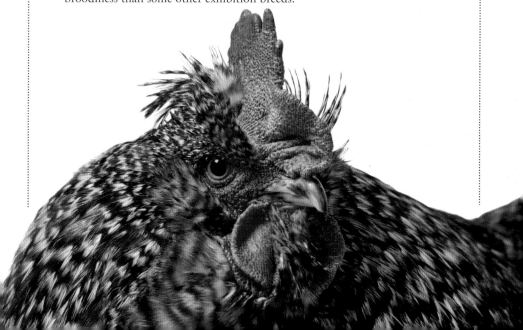

DORKING

One of the oldest breeds of chicken, the history of the Dorking is thought to stretch back to the days of the Roman Empire, where it originated in Italy at the time of Julius Caesar. It is mentioned by the Roman writer Columella, who describes it as 'square-framed, large and broad-breasted, with a big head and an upright comb.' The breed was then introduced into Britain where much of its development took place, and where it was used to produce the Faverolles and Sussex breeds. The Dorking is believed to have been first exhibited at a poultry show in 1845, and is still kept as a show bird today.

The Dorking is a largish breed, with males of the larger varieties (silver-gray and colored) weighing up to about 9 pounds (4.1 kg) and hens achieving about 7 pounds (3.2 kg). In the smaller white variety, males grow to 7.5 pounds (3.4 kg), the females achieving 6 pounds (2.8 kg) in weight. Bodies are rectangular, set on short legs bearing five toes. The combs are large, which means they can be prone to frostbite, even though the birds are fairly hardy otherwise. Although docile, the Dorking likes to forage and needs plenty of space to ensure its vigor. It is extremely popular on account of its white flesh and good flavor, but the bird is also kept for its white eggs.

FAVEROLLES

The Faverolles originated in the village of Faverolles in France, created by crossing breeds such as Dorkings, Houdans, and Asiatics. The breed was first described in 1893, with the salmon variety, now the most common, appearing in 1885. Faverolles were initially bred for their meat, but they are good egg-layers and are now seen as a dual-purpose breed.

The body of the Faverolles is broad and square and the wings are small. The broad, round head bears a single upright comb, a prominent beard, and muffling. The eyes are reddish-bay. The pinkish legs are sparsely covered, with the feathering concentrated on the outer toe. The feet have five toes.

The Faverolles is a docile, agreeable bird that can be tamed easily. They often become quite affectionate and are good as children's pets, living for around six or seven years. Faverolles are also alert and active. They prefer to live in a run, but because they are not good fliers fencing doesn't need to be too high. Because of their dense feathering and small combs they are quite resistant to cold weather, and can cope more readily with damp conditions than some of the other highly feathered breeds. Hens are broody and make good mothers, laying medium-sized cream or tinted eggs throughout the winter.

FRIZZLE

Although the Frizzle is thought to have originated in South-East Asia about 300 years ago, there are reports of the breed having been seen in Europe in the 1600s. The name Frizzle comes from the type's unusual feathering, in which a genetic modification causes each of the feathers to curl toward the head instead of the tail. Frizzles are popular as exhibition birds, particularly the smaller bantam forms, although the breed is considered rare. In fact, it was virtually extinct until its fortunes were revived by a group of enthusiasts which initiated a breeding program. Although the Frizzle is a recognized breed in many countries, frizzling is also present in other chicken populations and for this reason is considered by some authorities to be yet another variation that can occur in any breed.

Each of the Frizzle's feathers is moderately long and of a ragged appearance, making the bird's feathers seem permanently ruffled up. Frizzles hold their

bodies and their tails erect. They have short, broad bodies, rounded full breasts, long wings, and large upright tails, their legs being without feathering. The eyes, single comb, and wattles are red.

Despite their unusual appearance, Frizzles are hardy birds with equable temperaments. They are suitable for keeping in outdoor enclosures or can even be allowed to range free. The hens lay brown eggs, and the chicks, once hatched, begin to grow rapidly. They appear to have normal feathering at first, but soon begin to assume their characteristic ruffled appearance.

The Frizzle is available in a variety of colors, including black, white, buff, blue, black-and-red, and cuckoo, with the color of the beak corresponding to the color of the feathers. Three types of feathering can be present in the breed: frizzled, overfrizzled, and flat-coated.

A red-mottled Frizzle.

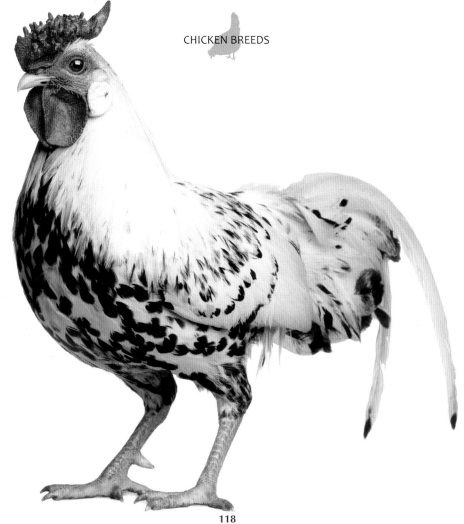

HAMBURG

Despite its German-sounding name, the Hamburg is an old breed that originated in the Netherlands, the breed shape having been further refined by English fanciers over a century ago. Known as Dutch Everyday Layers, their other name, Moonies, derives from the crescent moon-shaped spangles in the feather pattern.

This is an attractive breed kept mainly as an ornamental, and is available in several varieties. It lays small white eggs. The birds are neat in appearance, with pea combs. Hamburgs are quite alert and flighty chickens, capable of flying reasonably long distances. They are hardy and good at foraging, but do not take kindly to confinement. They are not especially docile and do not go broody.

Varieties include golden-spangled, silver-spangled, black, white, golden-penciled, and silver-penciled, some of which were developed in England and some in the Netherlands.

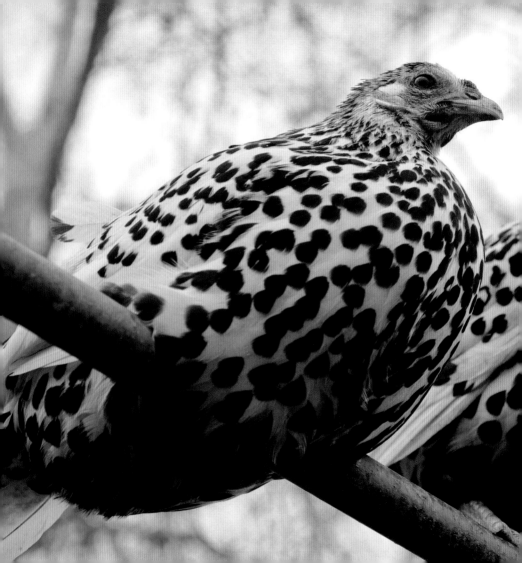

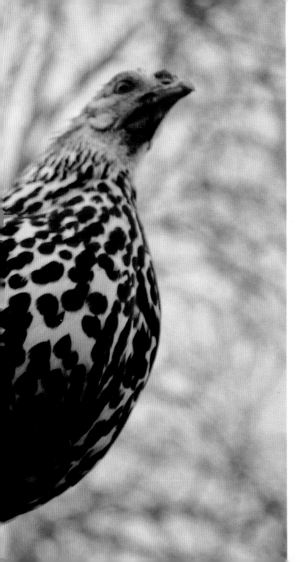

LEFT and OVERLEAF: The Hamburg has a most beautiful and distinctive feather pattern.

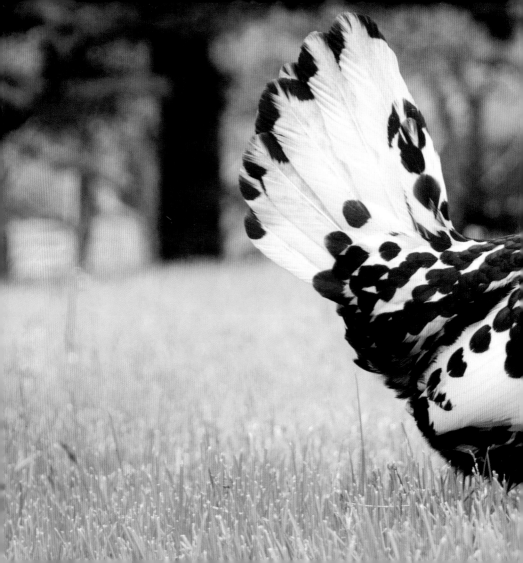

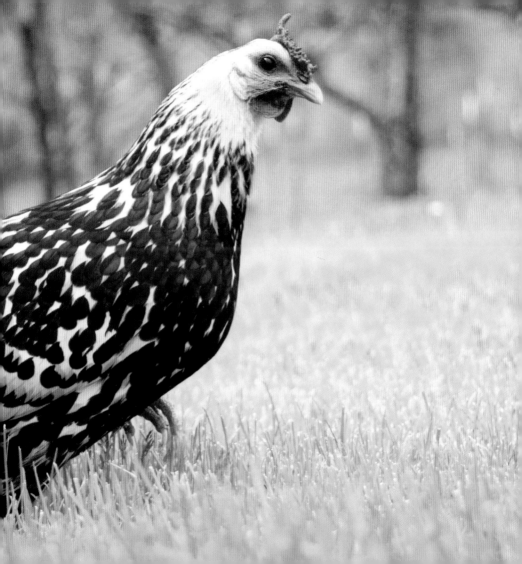

JAPANESE BANTAM

Also known in many parts of the world as the Chabo, thought to have come from a Javanese word meaning 'dwarf,' evidence suggests that the Japanese Bantam originated in South-East Asia, where it is still popular today.

This little chicken graced the gardens of the Japanese aristocracy for well over 350 years. The bantams began to appear in Japanese art in the mid-17th century, at a time when Japan was closing its doors to the outside world. It also appears in Dutch art of the same period, suggesting that Dutch traders possibly carried Chabos as gifts to the Japanese from spice ports in Java, which the Dutch ruled at that time.

This is a bantam breed, the birds having large, upright tails that can extend higher than their heads, while the wings angle down and to the back along the sides. The birds are friendly and make good pets, being fond of riding on the shoulders of their owners. They are capable of fending for themselves if provided with a large enough area in which to forage, but beware of putting too many roosters together; this may lead to fights despite their well-known friendliness. Japanese Bantams come in the following varieties: black-tailed white, white, buff, black-tailed buff, gray, blue, barred, black-breasted red, black, and many more.

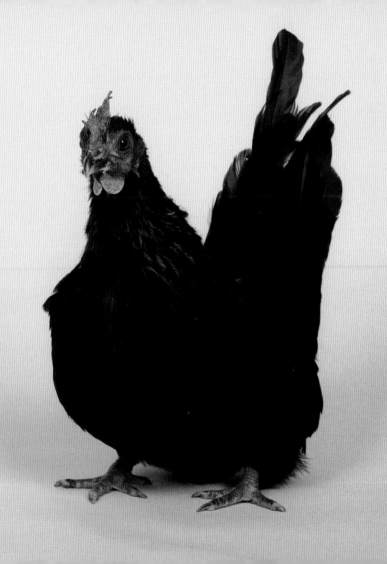

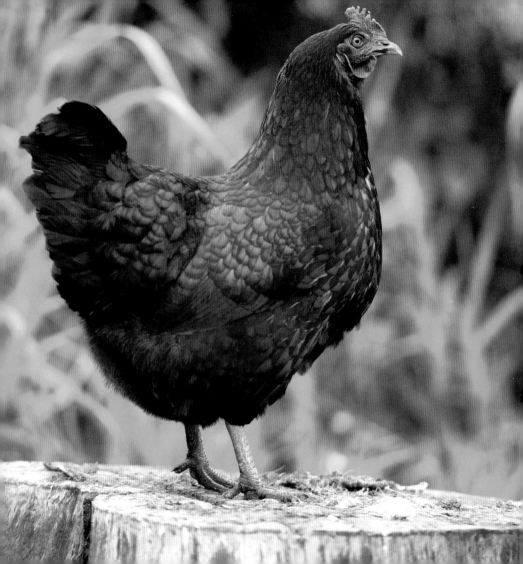

JERSEY GIANT

As the name suggests, the Jersey Giant is the largest of all the chicken breeds, having originated in the American state of New Jersey in the late 19th century. It was created by John and Thomas Black, whose aim it was to produce a turkey-sized chicken for use in meat production. The breed came into being by crossbreeding Black Javas, Dark Brahmas, and Black Langshans. The first Jersey Giant, the Black variety, was added to the Standard of Perfection of the American Poultry Association in 1922, with the White added in 1947.

This is a slow-growing variety, which is why it fell out of favor in the meat-producing industry. These days the Jersey Giant is seen as a rare breed and belongs therefore in the province of rare breed poultry shows.

This is a calm and good-natured breed. The hens are good layers of large, brown eggs. Plumage colors are blue, black, and white. Robust birds, Jerseys are tolerant of the cold.

127

LEGHORN

Another breed of chicken that takes its name from its place of origin, namely the port of Leghorn (Livorno) in Italy. It was subsequently further developed in other countries in Europe as well as in the USA, producing, from the original white form, the many color varieties that are seen today.

The Leghorn weighs about 3–4 pounds (1.4 kg–1.8 kg). Male Leghorns have especially prominent red combs, mostly single but sometimes double, and large wattles. Earlobes are white, beaks are short and stout, the long legs are yellow, and in all color varieties the eyes are red. Varieties include black, white, brown, blue, cuckoo, mottled, partridge, buff, and pyle.

Leghorns are prolific and productive layers throughout the year that can adapt to different types of conditions. The hens seldom go broody and are non-sitters, laying good-sized white eggs; the chicks are easy to rear, and grow quickly. Leghorns are happy to roam freely, roosting in trees if given the chance, but they can be kept equally successfully in a run. They are somewhat excitable, garrulous and active, becoming quite tame while preferring not to be handled. This breed is the foremost large-scale commercial egg-producer in the USA.

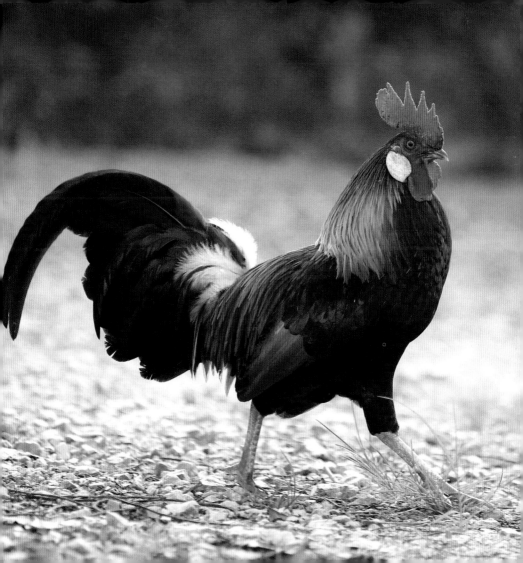

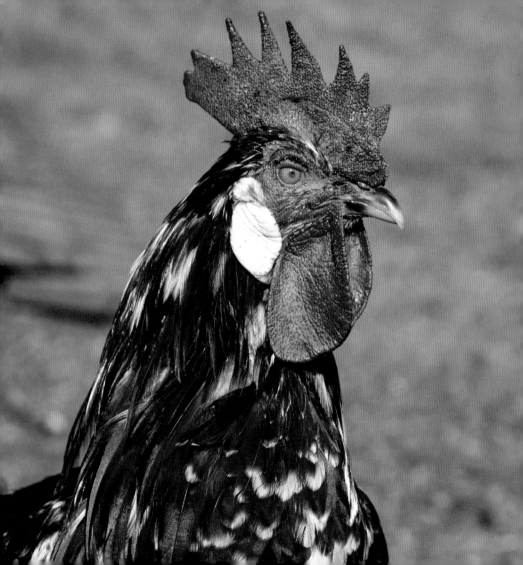

OPPOSITE: A Leghorn rooster. ABOVE: A Leghorn chick.

MALAY

This is an old breed that has changed very little over time. It is not known why it is called the Malay, for there is evidence that its descendants came from northern India. The Malay is somewhat different in appearance from many other chicken breeds. First, it has a slim, well-muscled body and an upright stance, making it appear taller and rather more 'wild' than some of the plumper, stockier breeds often seen. It also has very long legs. The lean look is even more pronounced because the birds are close-feathered, and often carry their bodies with their long necks held erect and their tails slightly drooping. The skull is large, and the bird's protruding beetle brow gives it a slightly fierce expression. Males grow to 9 pounds (4.1 kg) in weight, with females reaching 7 pounds (3.2 kg). The Malay was introduced to Britain in about 1830, and the black-breasted variety was admitted to the standard in 1883. Other varieties (see below) came much later.

In Asia, this chicken is seen around villages, but it is not especially prolific as an egg-layer (young hens may lay up to 100 or so brown eggs per year, but this diminishes to about 40 eggs in older hens). Another problem is that the bird's legs are so long that it is unable to fit easily into a standard nest.

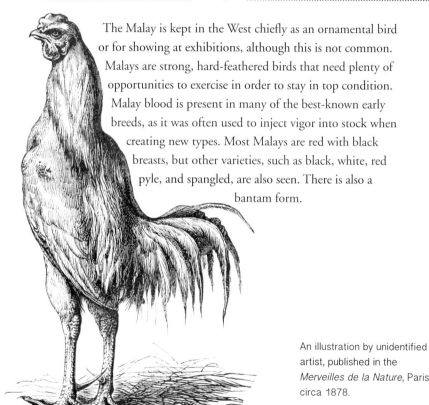

The Malay is kept in the West chiefly as an ornamental bird or for showing at exhibitions, although this is not common. Malays are strong, hard-feathered birds that need plenty of opportunities to exercise in order to stay in top condition. Malay blood is present in many of the best-known early breeds, as it was often used to inject vigor into stock when creating new types. Most Malays are red with black breasts, but other varieties, such as black, white, red pyle, and spangled, are also seen. There is also a bantam form.

An illustration by unidentified artist, published in the *Merveilles de la Nature*, Paris, circa 1878.

MARANS

The Marans is a breed of chicken that was developed in France, around the town of Marans, near La Rochelle. It is thought to contain elements of breeds such as Faverolles, Croad Langshan, and Barred Plymouth Rock in its makeup. It reached Britain in the 1920s, where its chocolate-brown eggs soon led to its widespread popularity.

Marans have broad, deep bodies and an overall attractive appearance. The large single red comb may have up to seven serrations and the earlobes and wattles are also red. The beak is medium-sized and light in color, and the eyes are orange-red. The medium-length legs are light in color and unfeathered. The most popular color – and perhaps the most appealing – is the cuckoo, ranging from dark gray to silver. A black form also exists, which has a beetle-green sheen to the feathers.

The Marans is an active and hardy chicken, popular in gardens where it keeps down the population of slugs, snails, and other pests. It is a good layer.

MINORCA

The Minorca was originally known as the Red-Faced Black Spanish. It is the largest and heaviest of the Mediterranean breeds, and good specimens present a stately appearance. The body is long and angular, making the birds appear even larger than they are. The tail is also long, and the large, wide feathers are held close to the body. The red comb is very prominent, the wattles are also long, and the earlobes are white. Males range from 8–9 pounds (3.6–4.1kg) in weight, the females achieving 6.5–7.5 pounds (3–3.4 kg).

Minorcas are alert birds that are well able to forage for themselves. They produce large white eggs, and yields are quite good. They are rather poor meat producers, however, due to their narrow bodies and slow rate of growth, but they are in any case bred mainly for their exhibition qualities. Varieties include single-comb black, single-comb white, single-comb buff, rose-comb white, and rose-comb black.

Published in *L'Illustration, Journal Universel*, Paris, 1858.

MODERN GAME

The Modern Game is a relatively old breed that originated in Britain between 1850 and 1900 following the ban on cockfighting in 1849. It was developed to be visually appealing, epitomizing the looks of the Gamecock or Fighting Cock. The breed was developed by crossing Old English Game and Malays and despite being classifed as a game chicken, it was not bred to fight, but was used for hobby or showing purposes.

Today, the ideal breed standard of the Modern Game includes a body shaped like a flat iron when viewed from above. The carriage should be upright, the tail fine, the back short, and the feathering hard. The Modern Game comes in a variety of colors, the most common being black, red, birchen, brown red, duckwing, and pyle. The comb and wattles vary from red to mulberry depending on the variety. The legs can be willow-colored or black.

In that they are kept for hobby and showing purposes rather than anything else, it is not surprising that the Modern Game is not renowned for its meat or eggs. But its temperament is quite friendly and it is easily tamed, making it a superb pet for both country- and suburban chicken-owners. Like many chicken breeds, the Modern Game can be of standard or bantam size, with the bantam being the most popular with enthusiasts.

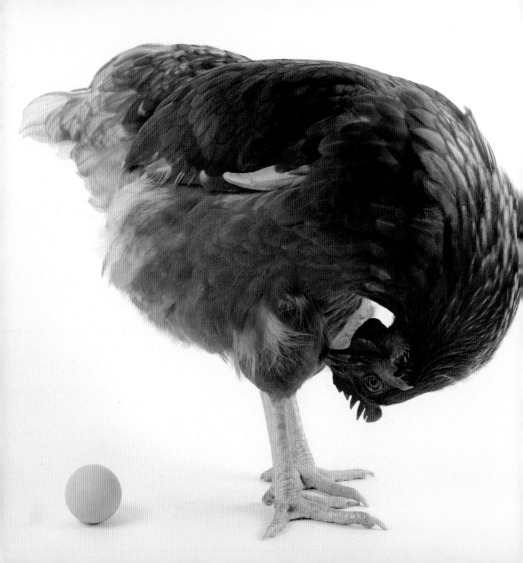

NEW HAMPSHIRE RED

This is another of those breeds that looks like a 'typical' chicken. The breed was developed over a number of years, beginning in about 1915, from specialized selections of the Rhode Island Red brought into the American state of New Hampshire. Since then, the breed is not known to have been diluted with any outside blood. The New Hampshire Red was admitted to the standard in 1935. Today its best qualities – and the ones sought after by breeders – are fast maturation, quick feathering, the production of large brown eggs, and general strength and vigor.

The body is deep-breasted and well-rounded with a medium-length tail. The head is deep and fairly flat on top with prominent eyes. There is a single comb with five points (that may fall slightly to one side in females), large wattles, and red earlobes. The legs are yellow, the lower thighs being large and muscular. The feet have four toes. The feathers are a rich chestnut red that have a tendency to fade in strong sunlight.

New Hampshire Reds do well either in runs or when allowed to range free. They aren't good fliers, so high fencing is not needed. They can cope with cold weather, but the combs are prone to frostbite, so care must be taken in such conditions. Hens lay well, even in winter; they are prone to broodiness and make good mothers.

OLD ENGLISH GAME

One of the oldest breeds of chicken, the Old English Game was first developed in England by the nobility for cockfighting throughout the Middle Ages. It was produced in various color varieties along with traits considered desirable for the sport. Following the ban on cockfighting, the Old English Game had a new role as a chicken breed, kept for poultry enthusiasts for showing and exhibition. Despite the amount of time that has passed since the cockfighting ban, the fowl has retained its aggressive and noisy temperament; even the hens are bad-tempered and should be kept separate from other more docile breeds, especially when they have chicks to look after. The males are particulary aggressive and must not be kept together, for they will fight to the death given half a chance! While the Old English Game is undoubtedly an attractive bird, its care should be the province of the experienced poultry keeper for obvious reasons. The hens are good layers and brooders.

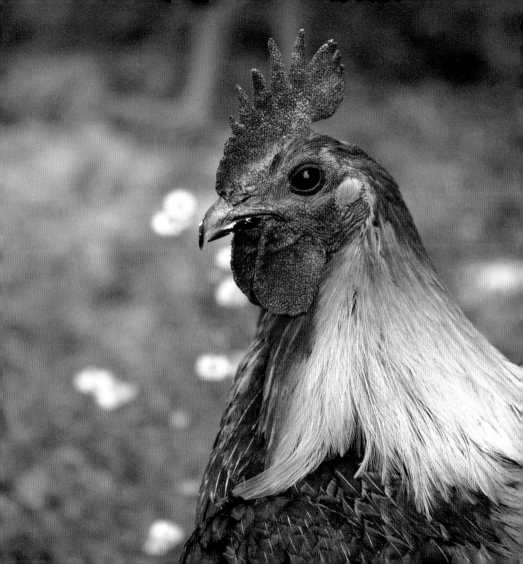

ORPINGTON

Coming from the town of Orpington in the English county of Kent in the 1880s, this breed was introduced to the USA in the 1890s, where it quickly achieved popularity due to the quality of its meat. The first Orpington, a black, was developed in 1886 by William Cook, who used Langshans, Minorcas, and Plymouth Rocks to create the breed. He then went on to develop the other solid-colored varieties. The Orpington is a dual-purpose chicken reared for its eggs as well as its meat. It is also popular as a show bird.

Because of its heavy, loose feathering, the breed can appear massive and stocky, but the generous feathering, which is extensive and almost covers the legs, also allows it to withstand colder temperatures than many other breeds. The birds have an upright stance, and heads that appear small in relation to the size of the body. The prominent combs are red, as are the wattles and cheeks. Dark-colored varieties (see following pages) have dark eyes and legs, whereas pale-colored varieties have red eyes and white legs.

Orpingtons adapt well to either free-range living or being confined in runs. They are fairly placid and tame, and when kept together seem to be non-aggressive toward other chicken breeds.

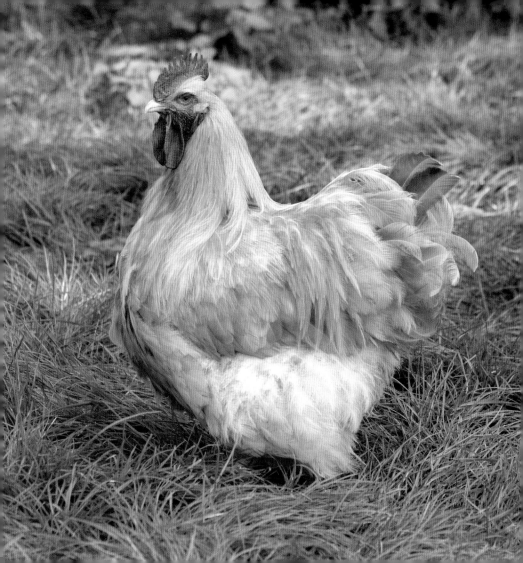

Hens show broodiness, laying small brownish eggs (about 150 per year), and make good mothers. Orpingtons like to exercise, but they have short wings and can therefore be kept in enclosures with low fences.

Orpingtons exist in various solid-color varieties: black (with a single comb or rose comb), blue, buff, and white. The lighter-colored buffs and whites are smaller than the darker varieties. Some new colors are also being bred, such as porcelain and red.

LEFT: A young Orpington.

OPPOSITE: An Orpington chick.

OVERLEAF: An Orpington hen and rooster.

PAVLOVSKAYA

The Pavlovskaya chicken first appeared in the town of Pavlovo in the Russian countryside about 200 miles from Moscow. As well as the breeding of Pavlovskaya chickens, the town became famous for breeding other birds, such as fighting geese and even canaries. Interestingly, but unrelated to the breeding of chickens, the town was also known for the excellence of its lemons.

Historians believe the Pavlovskaya to be the foundation for other breeds of chicken, notably the Polish Crested, which is one of the best-known varieties. During the Soviet era, numbers suffered and by the 1990s the breed was nearly extinct. Fortunately, however, the Pavlovskaya, due to a careful breeding program, was saved and today its numbers are slowly increasing.

The Pavlovskaya is a hardy bird, capable of withstanding cold Russian winters. It is known for the unique feathering on its feet, similar to that of wild grouse. The Pavlovskaya is quite small and it is a very flighty bird that lays a small number of small tinted eggs. It is known for its good looks and friendly personality. In the USA, meanwhile, specialist breeders are working to establish a healthy breeding population.

PEKIN

The Pekin is reputed to have been taken from the private collection of the Emperor of China in Peking (Beijing) by British forces in 1860, while another story describes how they were imported from China even earlier and presented to Queen Victoria. Either way, the Pekin, which is a true bantam variety, is known throughout most of the world as the Miniature Cochin, which can lead to confusion since the Pekin is a distinct breed and is not really a miniature version of a Cochin at all. No doubt some of this confusion arose because 'Cochin' was once the term used for all birds of this type coming from China, although today's Pekin bears little resemblance to the birds brought from that country all those years ago; these were taller and generally bigger, and generally held themselves in a more upright stance.

Beneath the fluffy exterior, the

Pekin has a short, robust body, the head being set slightly lower than the top of the tail. This gives the impression of the bird being tilted slightly forward – a feature regarded as important in showing circles. The small head, bearing a serrated comb, is set on a short neck surrounded by a hackle that reaches well down the back. The Pekin's legs are short and almost invisible beneath the fluffy covering of feathers. The bird comes in a variety of colors – too many according to some breed experts, who regard this overabundance as damaging to the breed standard. Colors include lavender, blue, black, buff, barred, Columbian, cuckoo, mottled, partridge, and white.

Pekins have endearing personalities; they are docile and friendly and look most attractive. They make good pets for children, although the feathering on the

OPPOSITE: A blue mottled
frizzled Pekin.

RIGHT: A black frizzled Pekin.

feet means that care must be taken to avoid them becoming wet and clogged with mud. Because they are small, Pekins can be kept in more limited spaces than might be possible for many other breeds, although they do like to forage for themselves on grass. The hens get broody and make excellent mothers, laying a fair number of tinted eggs at a time.

A chocolate frizzled Pekin.

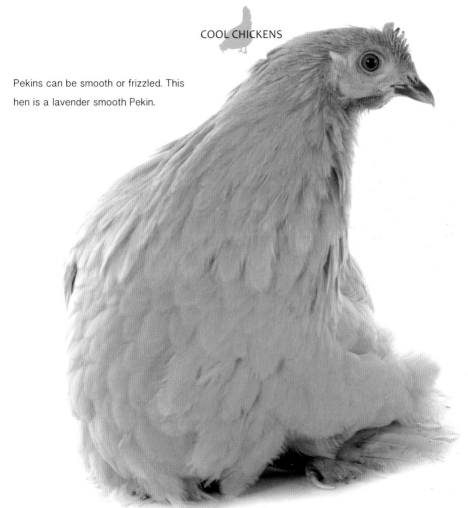

Pekins can be smooth or frizzled. This hen is a lavender smooth Pekin.

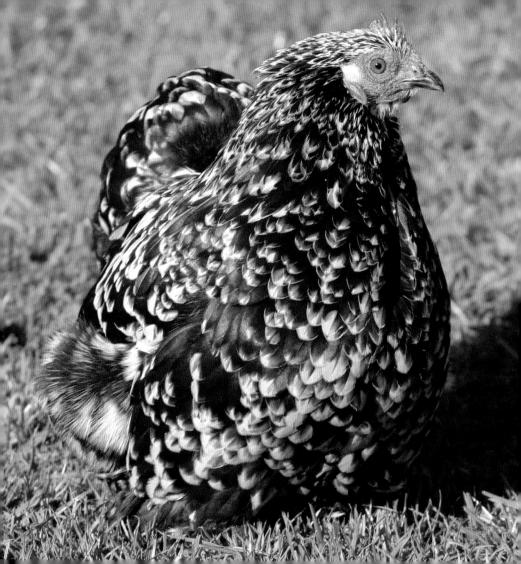

OPPOSITE and BELOW: Cuckoo-patterned
Pekins.

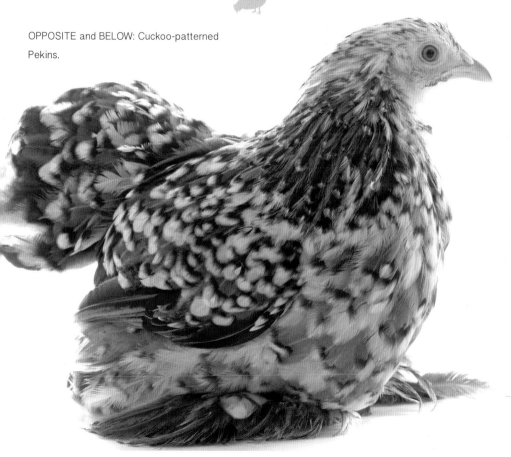

PHOENIX

A fascinating breed, known particularly for the length of its tail. the Phoenix was created by Hugo du Roi in the late 19th century when he crossed long-tailed Japanese breeds, such as the Onagadori, with other breeds such as the Leghorn, Malay, and the Modern and Old English Game.

The Onagadori has a recessive gene that prevents it from molting regularly in the usual way. The Phoenix, however, does molt each year or every other year, but retains more length in its tail feathers than other varieties of chicken. An alert bird, with a pheasant-like appearance, Phoenixes like to roam outside. Hens are good layers and do go broody.

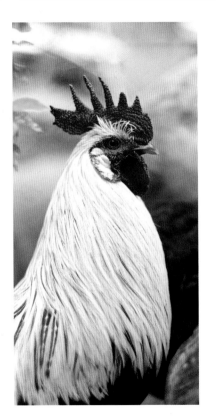

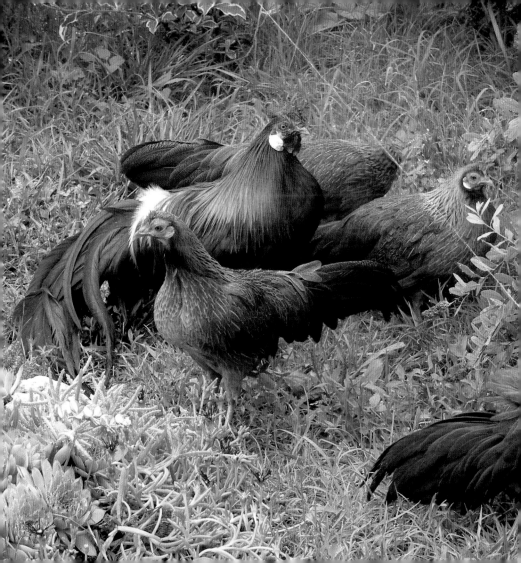

PLYMOUTH ROCK

This heavy breed, which takes its name from the New England town of Plymouth, was first exhibited in Boston in 1829 at America's first poultry show, but it is thought that the breed line of the original birds was lost, and the breed as we know it today was then exhibited again in 1869, at Worcester, Massachusetts.

The breed derived from crosses between several other breeds, including Dominique, Cochin, and Java, and possibly Dorking and Malay. The first Plymouth Rocks had barred plumage, and were in fact called Barred Plymouth Rocks, although other plumage patterns were later developed. The Plymouth

Rock was given full breed recognition in 1874, when it was included in the American Standard of Excellence.

The eggs are brown, but the particular shade may vary considerably. A hen may lay about 200 eggs in a year, and since the breed is prone to broodiness, frequent egg collection is advisable. Plymouth Rocks are big chickens and the hens have deep, full abdomens – an indication of a good egg-layer. The breed is also characterized by its broad, deep and well-rounded breast and bright yellow legs. The wattle, ear lobes and comb are red, and the bird has a bright-yellow beak and bay-colored eyes.

Plymouth Rocks are friendly birds that are easy to tame. Although they prefer to run free they do not require a great deal of space, and since they are poor fliers, fencing doesn't need to be built especially high. The chicks feather up quickly and the breed makes a good pet for children, being of a calm disposition as well as long-lived.

The breed comes in several varieties, including barred, buff (first exhibited as golden-buff), Columbian, partridge, silver-penciled and white.

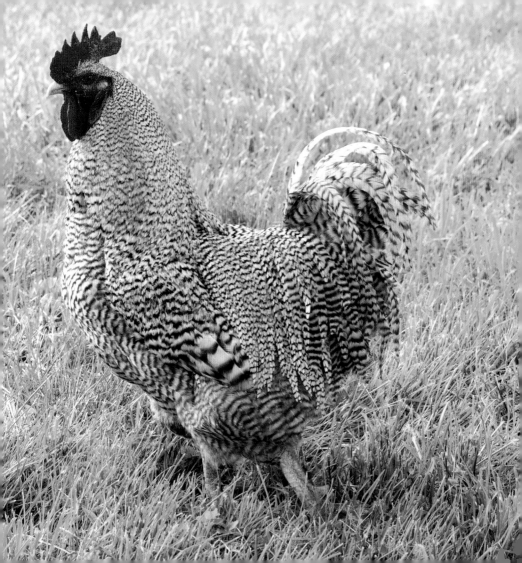

POLAND (POLISH)

The Poland is an ancient breed whose origins – and even the reason for its name – are unclear. Crested birds of this type have been described in many parts of Europe, not only in Poland, and it was known as a pure breed as far back as the 16th century. The Poland was shown at the first poultry show in London, England, in 1845, where it was able to achieve breed classification.

As mentioned, this is one of the crested breeds. The bird has an upright stance, a tightly feathered body, and showy, erect tail feathers, but it is the head that attracts all the attention – the crest seemingly having a central parting, with the feathers fanning out on either side. Some also have a beard and muffs. Breeders and keepers of this chicken sometimes tie the crest up to keep it clean and to enable the

LEFT: A lace-crested Poland.

OPPOSITE: A chamois-crested Poland.

164

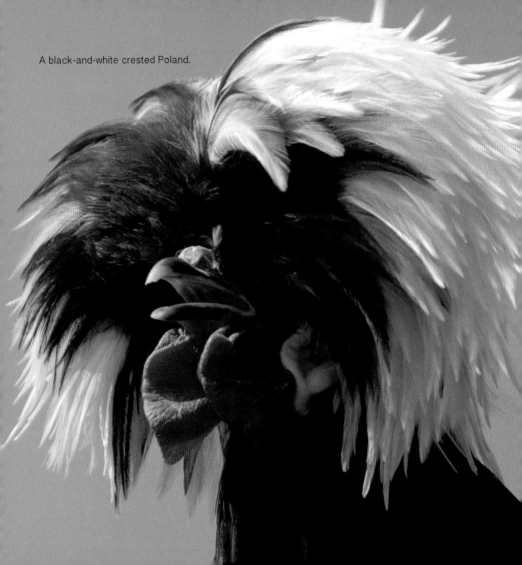

A black-and-white crested Poland.

bird to get a better view of the world. The crest of the male is spiky, whereas that of the female is more rounded. The eyes are red in all color varieties.

The Poland is described as a non-sitter, laying white eggs, but it can occasionally become broody. It is best to use an incubator. It needs plenty of space in which to roam, as overcrowding can lead to crest-plucking behavior. It should also be kept warm in cold weather, because it has a relatively thin skull and is susceptible to the effects of hypothermia. Furthermore, ice can form in its crest when it drinks, which can cause problems, as can mites, which the bird finds difficult to remove by preening.

The Poland comes in various colors, the best-known being the white-crested black, i.e., a black body with a white crest. The other two similarly-patterned types are the white-crested blue and the white-crested cuckoo. In these aforementioned color

A white-crested Poland.

167

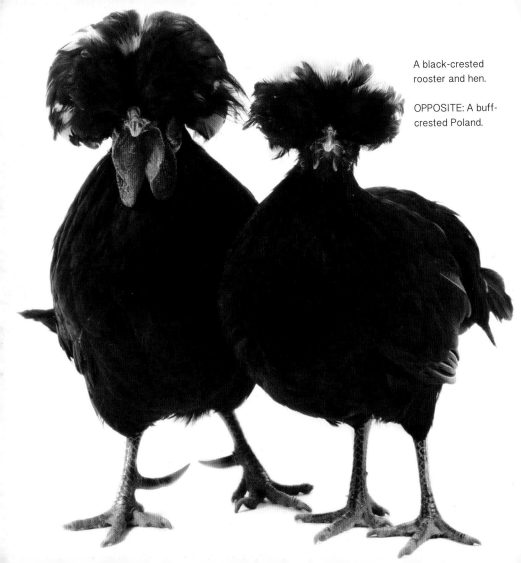

A black-crested rooster and hen.

OPPOSITE: A buff-crested Poland.

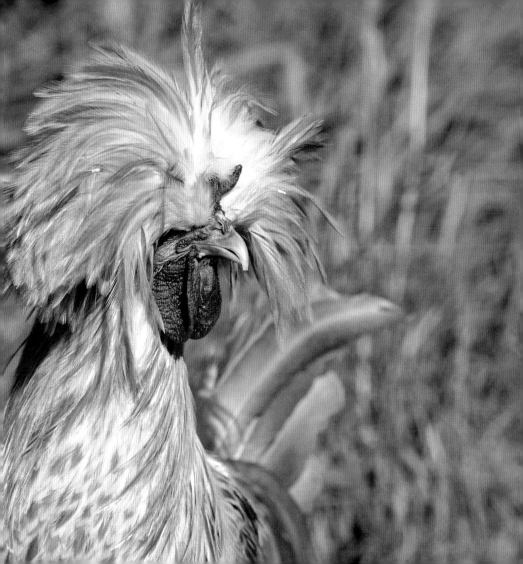

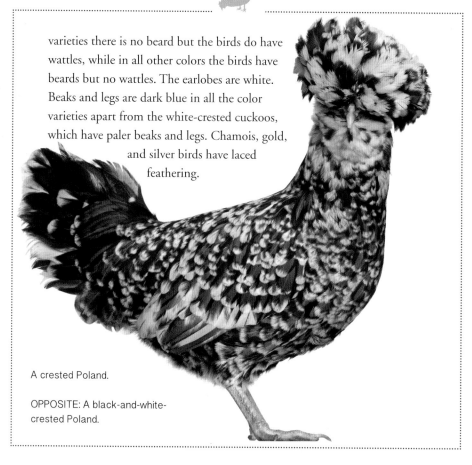

varieties there is no beard but the birds do have wattles, while in all other colors the birds have beards but no wattles. The earlobes are white. Beaks and legs are dark blue in all the color varieties apart from the white-crested cuckoos, which have paler beaks and legs. Chamois, gold, and silver birds have laced feathering.

A crested Poland.

OPPOSITE: A black-and-white-crested Poland.

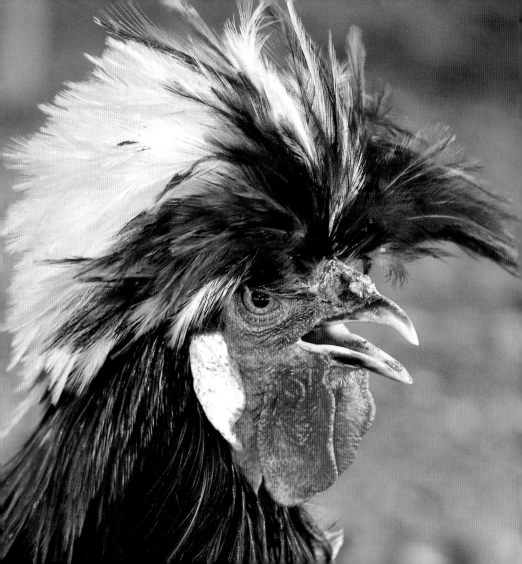

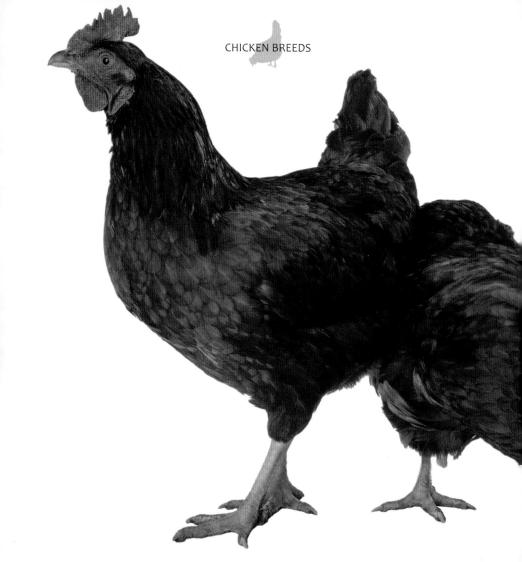

RHODE ISLAND RED

Developed in the eastern American state of Rhode Island in around the 1890s, the breed occurred by way of crossings with other breeds, including Leghorns, Malays, and Cochins. It is from the Malay that the Rhode Island Red derives its deep-red feathers. Original birds had both single and rose combs, or even pea combs. The Rhode Island Red is an important dual-purpose bird, and today it is arguably the best-known breed throughout the world. It was introduced to Britain in 1903, where its popularity expanded quickly, and crossings of the Rhode Island with the native Sussex breed produced many of Britain's modern chicken hybrids.

As the name suggests, the Rhode Island Red has rich, dark, glossy red plumage, this being especially handsome in the males. Black feathering can be present in the wings and tail, but only the female should have black feathers on the neck. The comb, wattles, eyes, and earlobes are also red, and the legs are yellow. The body is rectangular, broad and deep, with a flat back and a medium-sized tail. Although the Rhode Island Red is classed as a

heavy breed, it is active and fairly hardy. It can make a good pet, but some males may be aggressive. It enjoys foraging and can cope with marginal conditions better than many other breeds. Rhode Island Reds are probably the best egg-layers of the dual-purpose breeds, producing plenty of brown or dark-brown eggs.

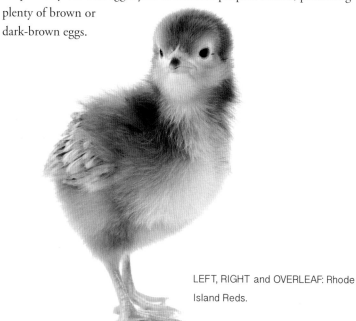

LEFT, RIGHT and OVERLEAF: Rhode Island Reds.

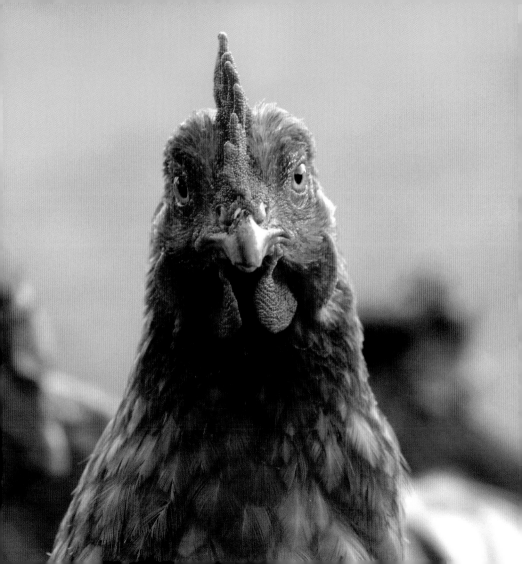

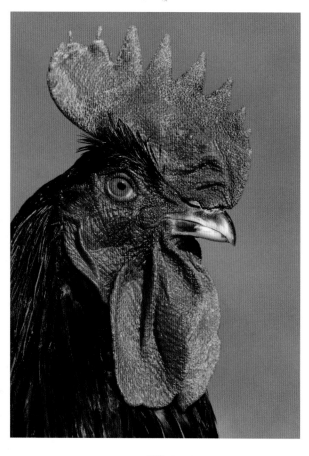

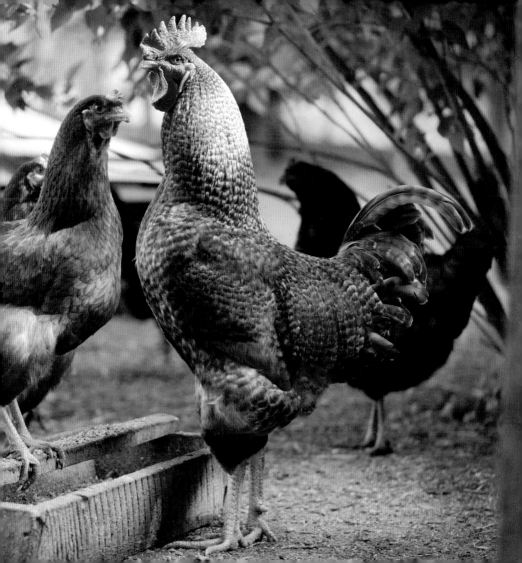

SCOTS DUMPY

The Scots Dumpy is thought to have originated in Scotland, the 'dumpy' part of the name, meaning short and stout, referring to the breed's thick-set appearance and extremely short legs. But historically they have been known under a host of names, such as Bakies, Stumpies, Dadlies, Hoodies, and Creepies, and were probably the birds referred to in Gaelic as *Coileachchime* and *Coileach degh sheinneadair*.

Shortness of leg is the breed's most defining characteristic, producing a waddling gait, with adult birds being less that 2 inches (5cm) off the ground. The birds are also longer in the back and have tails that are set lower than in other breeds.

There are no set colors for the Scots Dumpy, but cuckoo, black, and white are the most common. Other patterns/colors occur as sports, or have been bred into the phenotype by fanciers. The breed's standard allows for any pattern/color that is allowed in game fowl, although color is only worth 10 percent of the score in competition.

On the whole, this is a docile breed but, as in any breed, occasional males can be aggressive. Hens are good layers of light or white to tinted eggs, and are said to make good table birds.

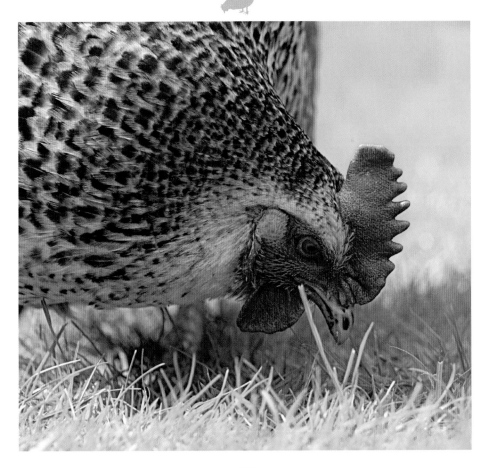

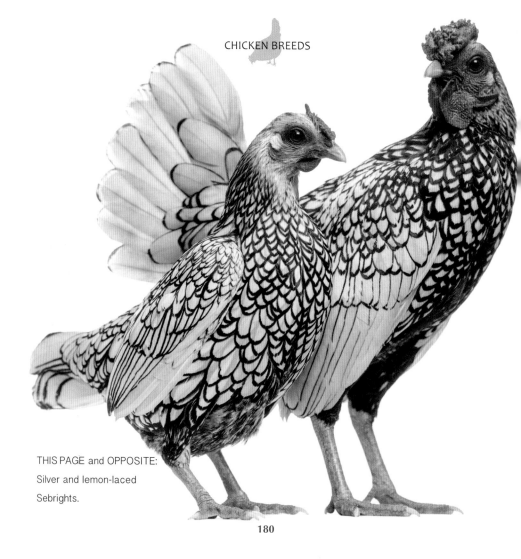

THIS PAGE and OPPOSITE:
Silver and lemon-laced
Sebrights.

SEBRIGHT

Another true bantam with no standard form, the Sebright is one of the most popular of breeds, due largely to the extraordinary laced appearance of its feathering. It bears the name of Sir John Sebright, the person who developed it over 200 years ago, and although there is some doubt concerning the actual breeds used in his endeavor, it is likely that they included Nankin, Poland and Hamburg chickens. Sebright established a club for his breed in 1810, and development continued, including the creation of the gold and silver varieties seen today. The breed standard was established in 1952.

Although small, Sebrights carry themselves with confidence. The body is compact, having a short back and a full, puffed-out breast. The wings seem slightly large, given the size of the bird, and they are

carried low and angled down toward the ground. The tail is well-fanned and carried high.

Male Sebrights usually lack the big, curved sickle feathering that is seen in the tails of most males, having what is known instead as hen feathering. The result is that the feathering appears sleek and neat in both sexes.

The head is small with a short beak which is dark blue or horn-colored in silver varieties, but a darker horn-color in golden varieties. Males have rose combs with fine points. The feathering on the gold variety appears as a golden-bay background coupled with the strong, well-defined black lacing that has a greenish sheen in the light. The feathers of the silver variety have a silvery-white background color with the same black lacing. In both varieties the legs and feet are slate gray.

The Sebright is a difficult bird to rear, with a high mortality rate in its first few weeks of life, making it unsuitable for novice breeders. The attractive feathering makes the bird a favorite with exhibitors, but it is also a suitable breed to keep as a pet in the garden, even as a member of a mixed flock. Sebrights are curious and good-natured, being hardy and with a fondness for ranging free. They also like to fly. Eggs have light-colored shells, although egg-laying performance varies and the hens are not especially broody.

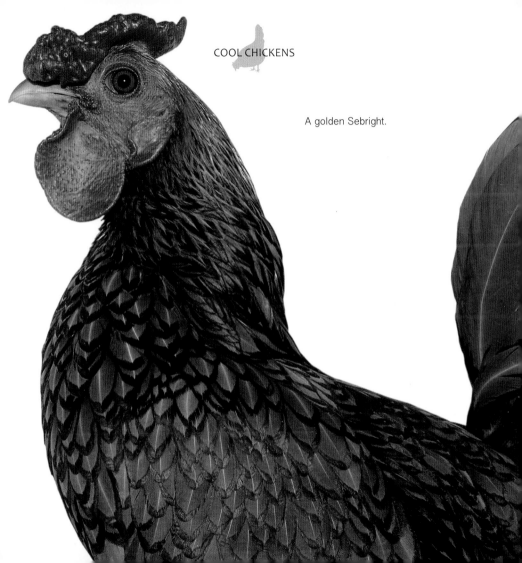

A golden Sebright.

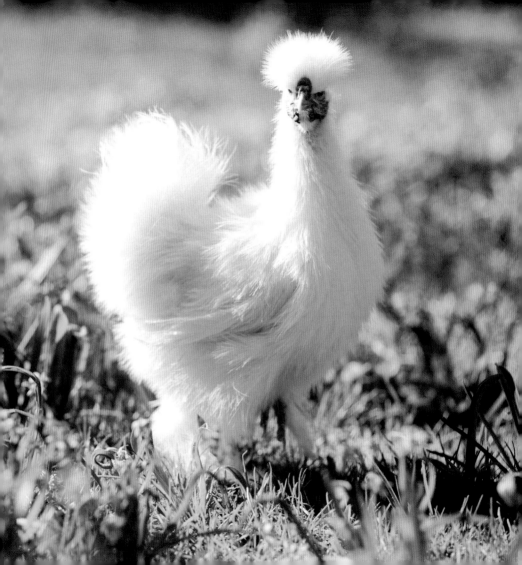

SILKIE (SILKY)

A most unusual-looking chicken, the Silkie is a small variety that ranks among the 15 or so most popular breeds in the USA. Of ancient Asian stock, the Silkie's exact origins are shrouded in mystery, as is the case with many of the older breeds. What is not in doubt, however, is that the Silkie has been known for hundreds of years. The great traveler Marco Polo describes seeing a 'furry chicken' on his travels in China in the 13th century, and the description is in some ways accurate, for the unusual feathering of the Silkie does resemble a covering of soft fur. When trade routes were established between East and West, the Silkie was brought to Europe; much later, the bird was advertised and sold in the Netherlands as a cross between a chicken and a rabbit!

As mentioned, the Silkie has fur-like feathering, the unexpectedness of it producing an almost comical appearance, and it is this soft-looking plumage that has given the bird its name. The look is completed by a powder-puff crest on the top of the head and in some varieties even fluffy ear muffs and a beard. The feathering extends right down to the feet. The skin, including the comb and wattles, is a purple-blue color, with blue earlobes. When produced for the table, the unusual dark skin seems very strange in a cooked bird – a surprise heightened by the fact that the bones are also nearly black in color.

Although they are small, and some people are confused into calling them bantams, they are in fact a small example of a standard breed. A true bantam variety also exists, however, which is only two-thirds the size of the standard bird. It was officially recognized in Britain in 1993.

Male Silkies have broad, full bodies with short backs. Tails and

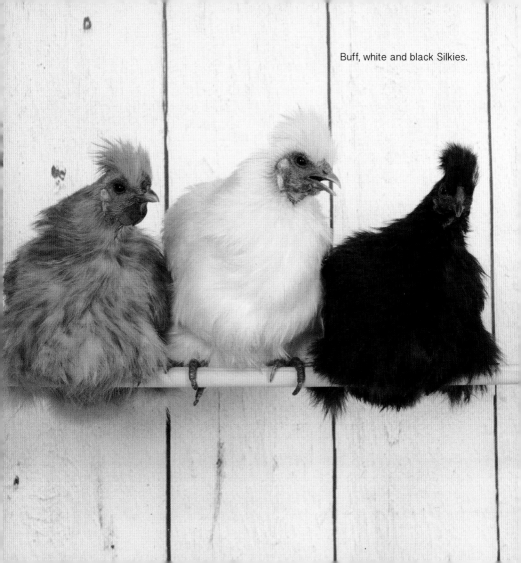

Buff, white and black Silkies.

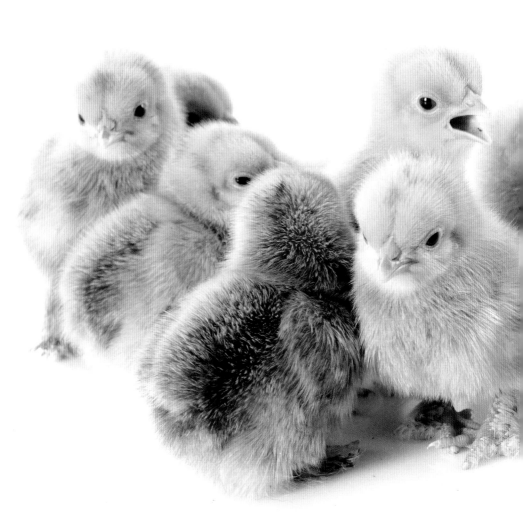

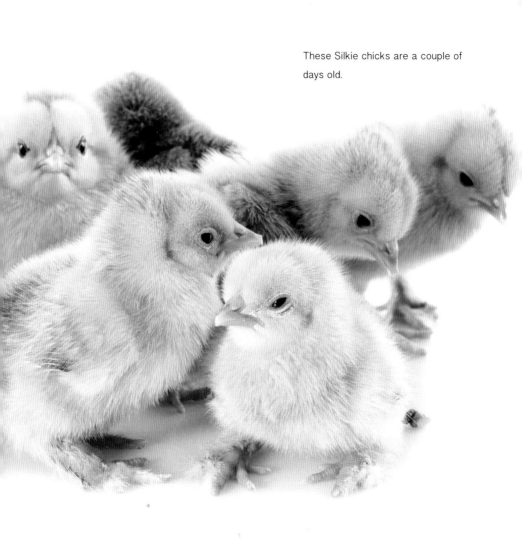

These Silkie chicks are a couple of days old.

wings have a ragged appearance, especially at the tips of the feathers. The head bears a walnut-type comb, black eyes, and a short beak. The legs are dark gray. This is another breed in which the foot has five toes. Females have shorter legs, with their underfeathers almost touching the ground. The comb, wattles, and earlobes are smaller in the female. The Silkie comes in black, white, blue, gold, and partridge colors.

Silkies are calm and gentle birds and could almost be termed the perfect pet but for their need to avoid wet or muddy conditions, which can cause problems with the plumage and promote mite diseases such as scaly leg. Feeders and water containers should also be positioned so that feathers do not become soiled, since this can again lead to parasitic infections. Silkies do not fly and don't seem to mind being reasonably confined. They don't mix well with other chickens, however, so need to be kept apart.

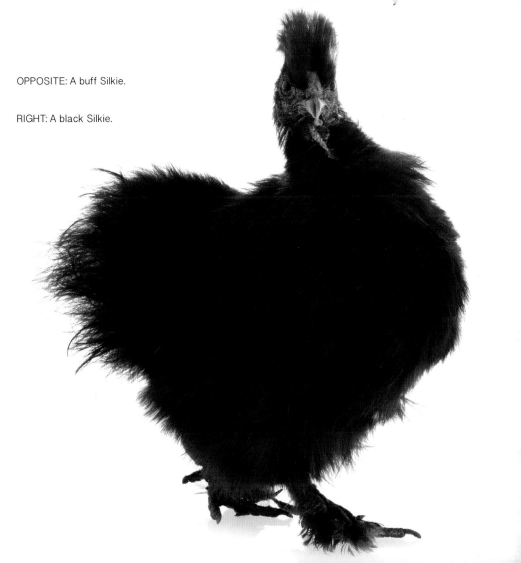

OPPOSITE: A buff Silkie.

RIGHT: A black Silkie.

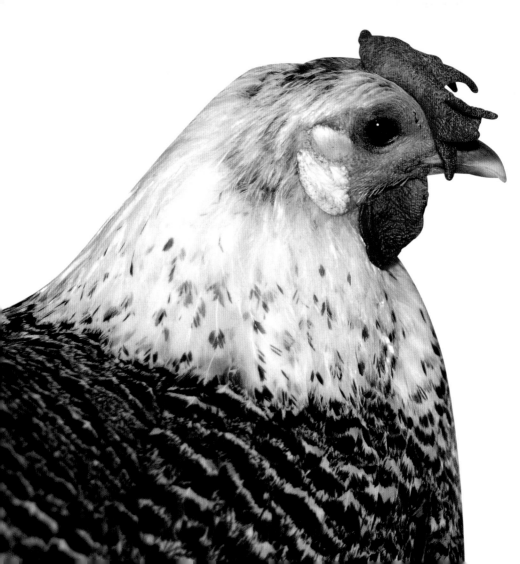

SUSSEX

This attractive breed comes from the southern English county of Sussex. One of the oldest chicken breeds, the Sussex was a popular bird over 100 years ago and is still so today. Although bred as a dual-purpose bird, the Sussex chicken is a prolific egg-layer. It is now found in many countries, where it is often described as a typical 'backyard chicken.' The breed is also exhibited at shows.

The Sussex is a graceful, well-proportioned bird with a flattish back and with the tail held up at an angle of about 45 degrees from the body. Feathering is quite dense and also extends well down the legs. The medium-sized red comb is single and erect, and the wattle is fairly long in the male bird. The earlobes are also red, as are the eyes in the dark-colored varieties, being orange in the lighter colors. The legs are white.

The Sussex is a docile bird and a good forager, and adapts well to a free-ranging life, although it can also be kept successfully in more confined conditions. Hens may sometimes go broody, especially those of the speckled variety. About 250 large, cream or light-brown eggs are produced each year, and resulting chicks are fast to mature.

WELSUMMER

The Welsummer gets its name from the Dutch village of Welsum, despite the fact that it was actually developed in the region to the north of Deventer at about the same time (1900–13) that the Barnevelder breed was being created. The Welsummer arose from crossings between the Cochin, Wyandotte, Leghorn, Barnevelder, and Rhode Island Red. In 1921 the Welsummer was exhibited at the World Poultry Congress in The Hague, Holland, and in 1928 was introduced to Britain. It is a fairly common breed today.

The Welsummer male has the look of a typical farmyard cockerel, being upright and with a broad back and big, full tail held erect. The head bears a large red comb, medium-length wattles, almond-shaped earlobes, and a short, strong beak. The legs are yellow.

Welsummers forage well when allowed to range free, although they can also be kept in runs. Hens go broody and lay large, brown, pigmented eggs, although there are fewer in winter. Chicks are easy to sex because males have lighter-colored heads than the females, and back markings. Varieties such as silver duckwing, gold, and black-red partridge are possible.

These are friendly, easy-to-handle birds which live for about nine years.

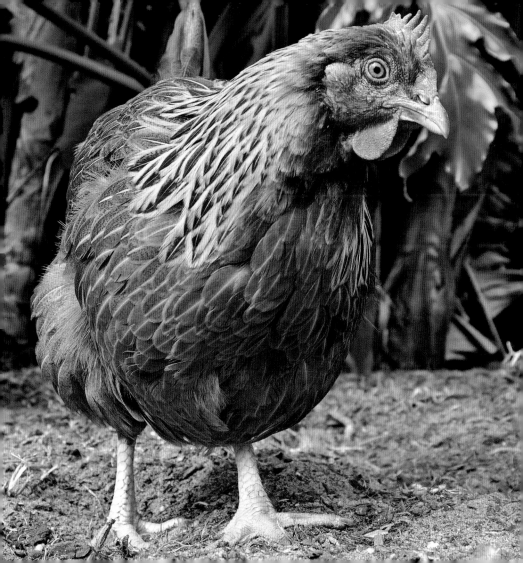

WYANDOTTE

The Wyandotte originated in the United States, although the breeds used in its creation are not clear. The first variety, the silver-laced, was developed in New York State in the 1860s, where it became known as the American Sebright or Sebright Cochin. The other varieties were created in the north and north-eastern states in the 19th and 20th centuries, and the Wyandotte is now a fairly common breed.

Wyandottes are large chickens with a noticeably rounded appearance, their bodies being broad and full-feathered. Hens are deep-breasted, indicating they are good egg-layers. The Wyandotte has a short, round head, a rose comb, bright-red earlobes, and reddish eyes.

Wyandottes are a good dual-purpose breed. They tend to be docile birds, and the hens make good mothers, being productive layers of brown eggs, and have strong,

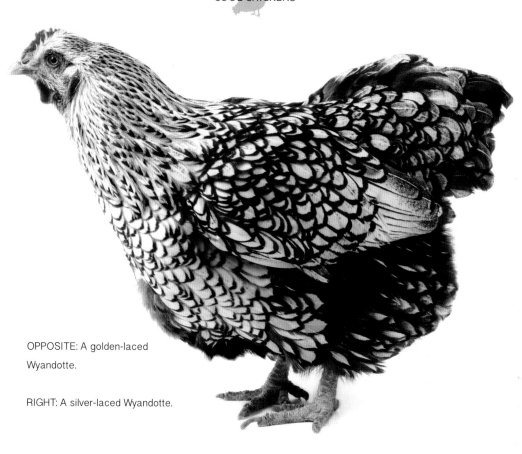

OPPOSITE: A golden-laced
Wyandotte.

RIGHT: A silver-laced Wyandotte.

quick-growing chicks. They have good temperaments, an attractive body-shape and plumage-patterning, and an ability to remain healthy even in adverse conditions, making them popular with chicken fanciers and farmers.

The Wyandotte is available in several colors and patterns, including white, blue, buff, black, partridge, silver-laced, silver, gold, gold-laced, blue, buff-laced, and Columbian – which is not so very different from the plumage of the light Sussex bird.

LEFT and OPPOSITE: A silver-laced Wyandotte.

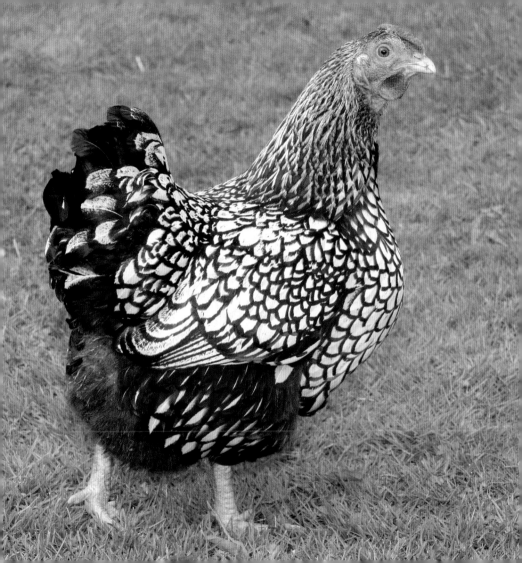

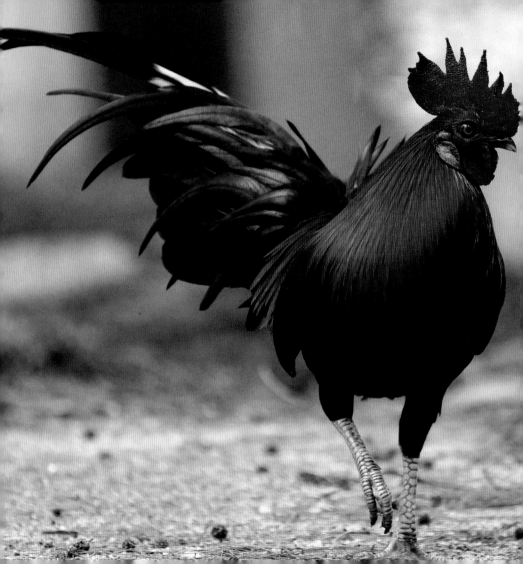

FACTS
ABOUT
CHICKENS

The average hen lays 200–300 eggs per year when in her prime.

There are more than 24 billion chickens in the world – making it more numerous than any other bird species in the world.

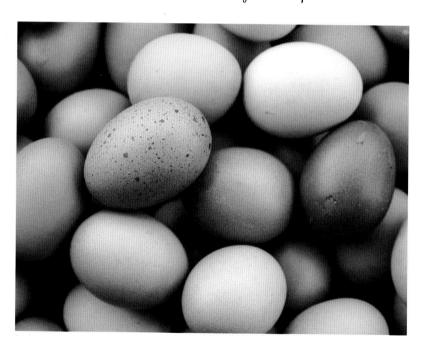

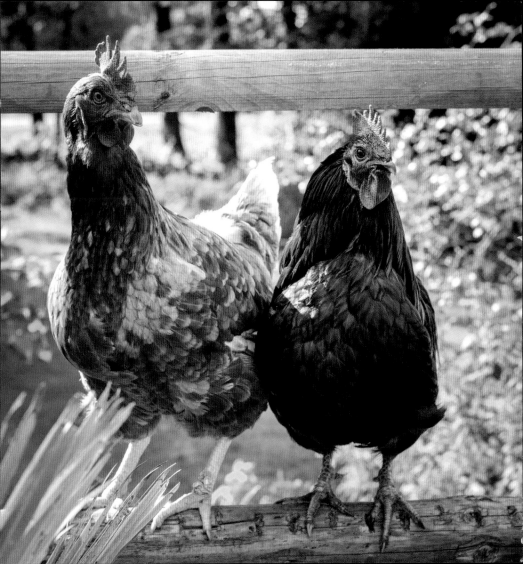

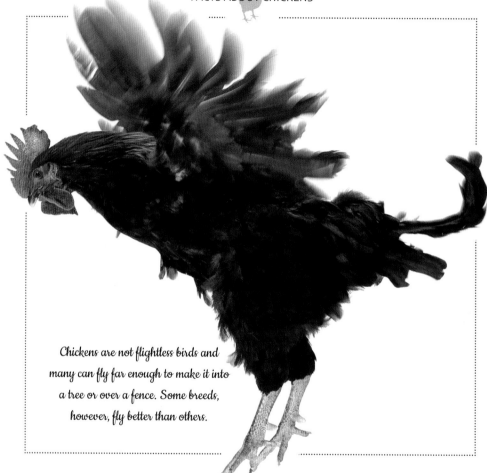

Chickens are not flightless birds and
many can fly far enough to make it into
a tree or over a fence. Some breeds,
however, fly better than others.

COOL CHICKENS

Chickens are omnivores and will eat insects and seeds as part of their normal diet. They are also known, on occasion, to take small mammals such as mice.

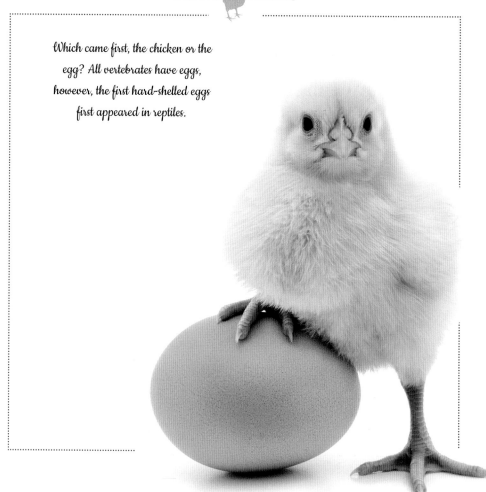

Which came first, the chicken or the egg? All vertebrates have eggs, however, the first hard-shelled eggs first appeared in reptiles.

Chickens love a dust bath. It helps keep the skin and feathers in good condition.

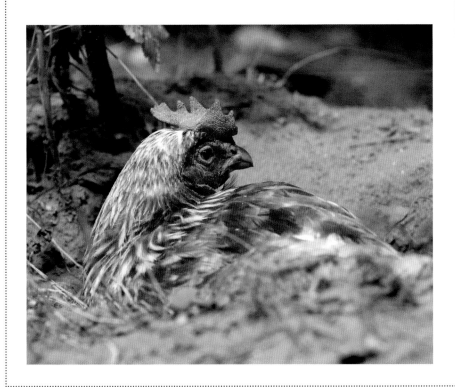

Chickens like to play. These three are clearly enjoying perching and modeling these chunky knits.

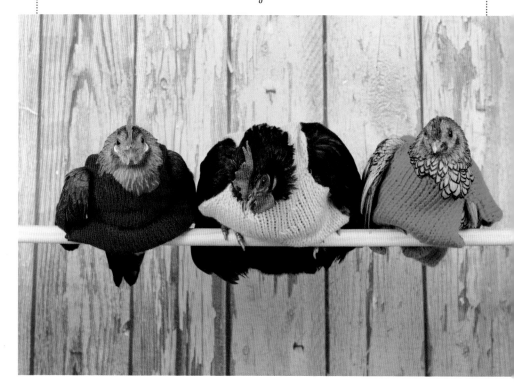

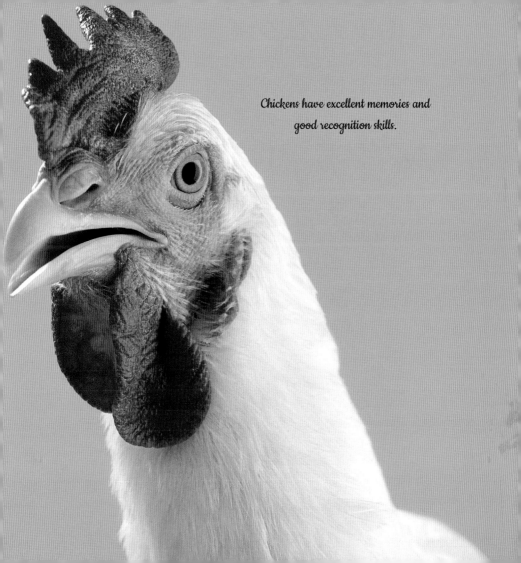

Chickens have excellent memories and
good recognition skills.

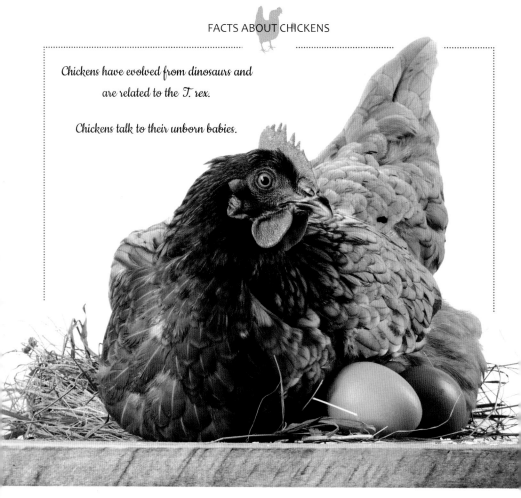

Chickens have evolved from dinosaurs and
are related to the T. rex.

Chickens talk to their unborn babies.

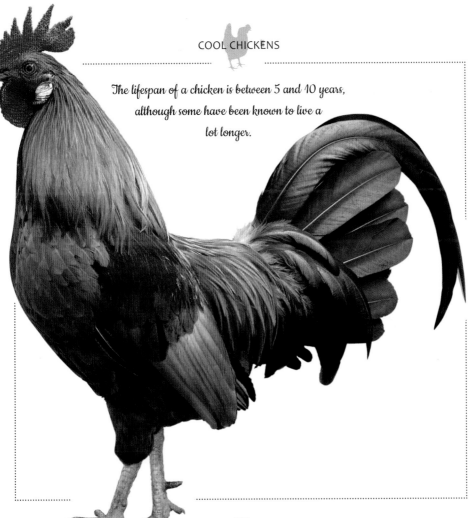

The lifespan of a chicken is between 5 and 10 years, although some have been known to live a lot longer.

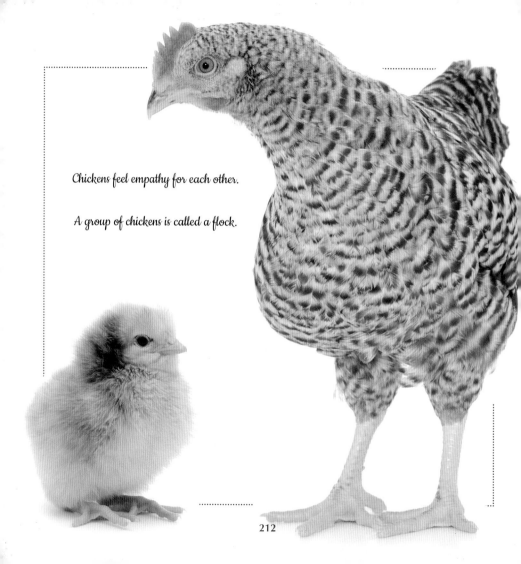

Chickens feel empathy for each other.

A group of chickens is called a flock.

212

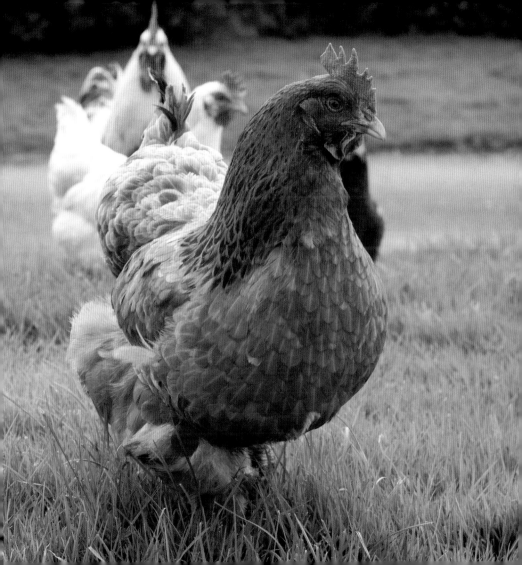

Chickens can recognize other chickens in their flock and they can also recognize their human owners.

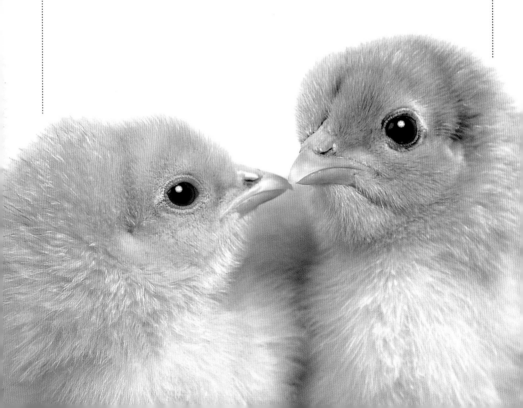

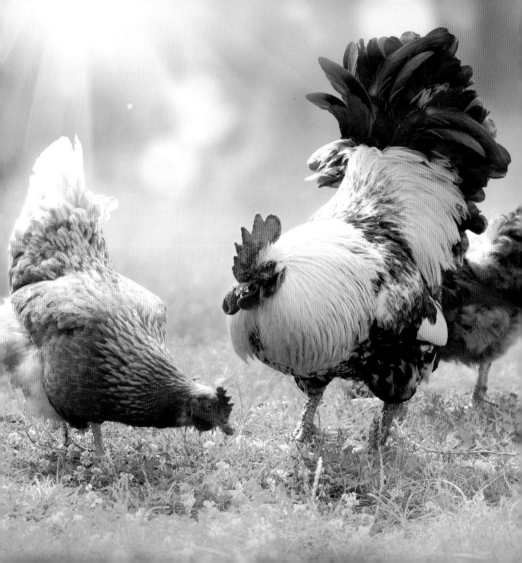

FACTS ABOUT CHICKENS

Like other birds and mammals, chickens experience REM sleep which is associated with dreaming.

Chickens form complex relationships with social behavior and a dominance hierarchy. This is where the term "pecking order" comes from.

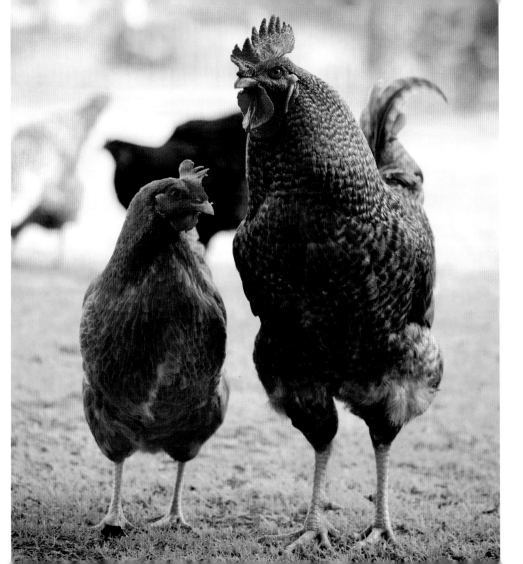

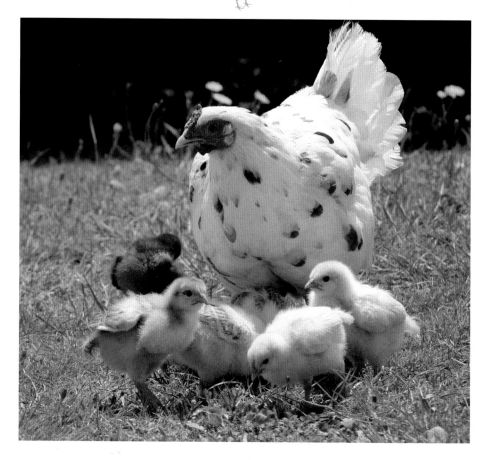

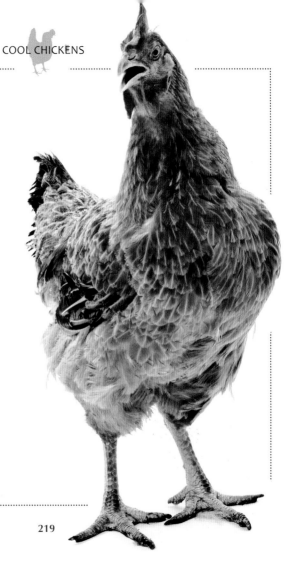

Hens are affectionate and caring mothers.

Chickens perform many types of vocalization varying from communicating with youngsters, alarm calls, and alerting others to a food supply.

Chickens have color vision.

A mother hen turns her eggs many times a day.

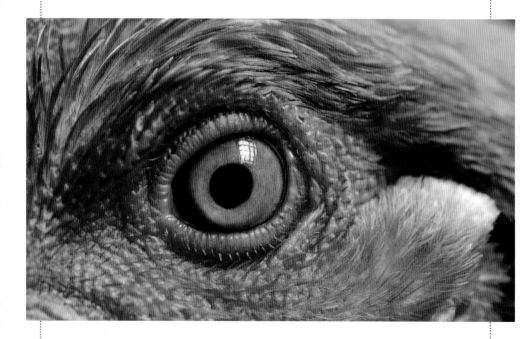

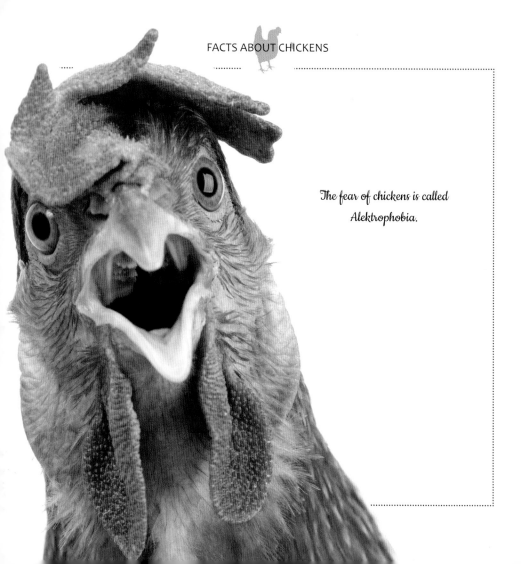

The fear of chickens is called
Alektrophobia.

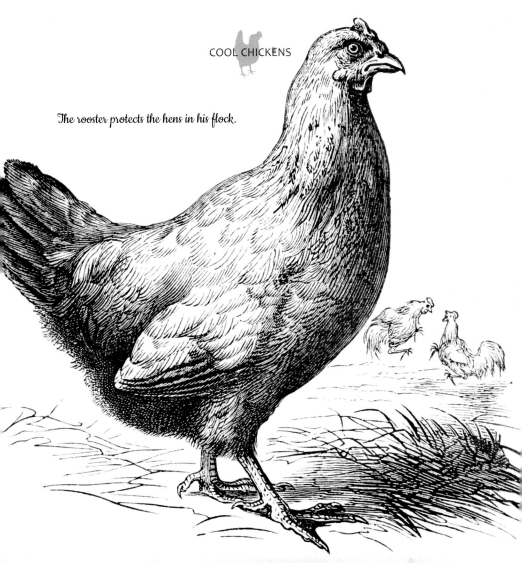

COOL CHICKENS

The rooster protects the hens in his flock.

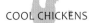

A chicken's heart can beat more than
300 times a minute.

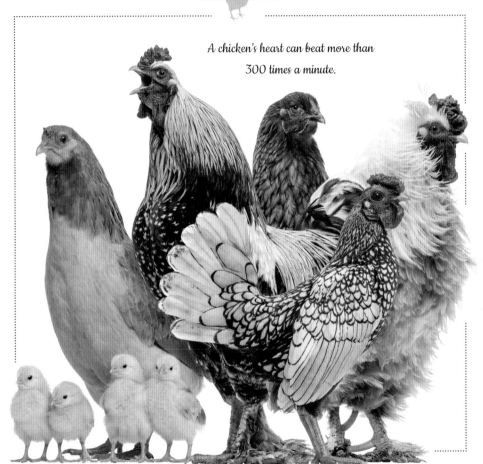

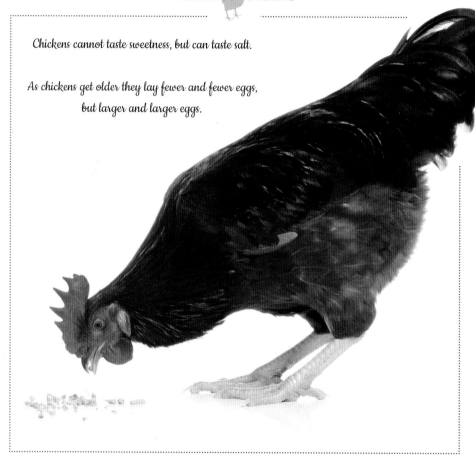

Chickens cannot taste sweetness, but can taste salt.

As chickens get older they lay fewer and fewer eggs,
but larger and larger eggs.

FACTS ABOUT CHICKENS

A chicken can lose its feathers when stressed.

Most chickens lay one or two eggs a day on average.

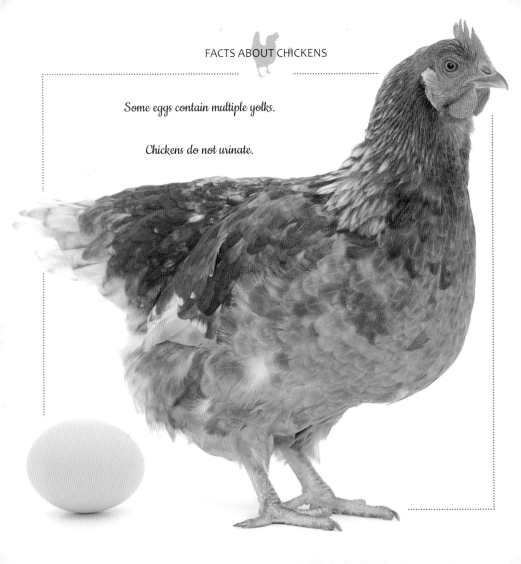

Some eggs contain multiple yolks.

Chickens do not urinate.

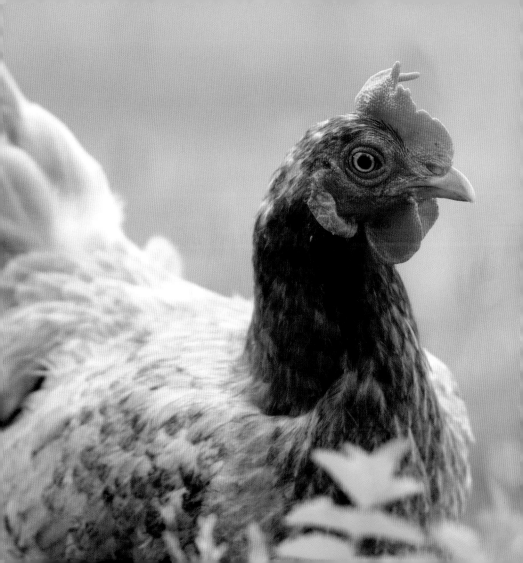

A chicken can run at about 9 miles per hour.

A chicken can have 4 or 5 toes on each foot.

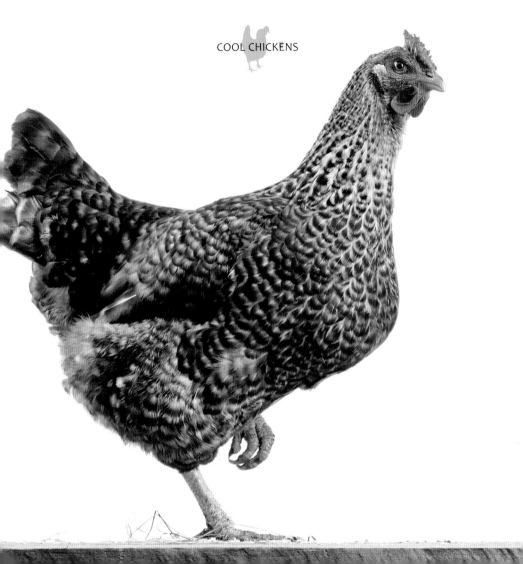

COOL CHICKENS

Hens require a warm, safe place in
which to hatch their chicks.

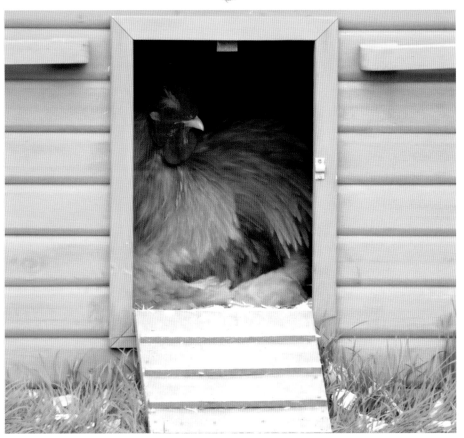

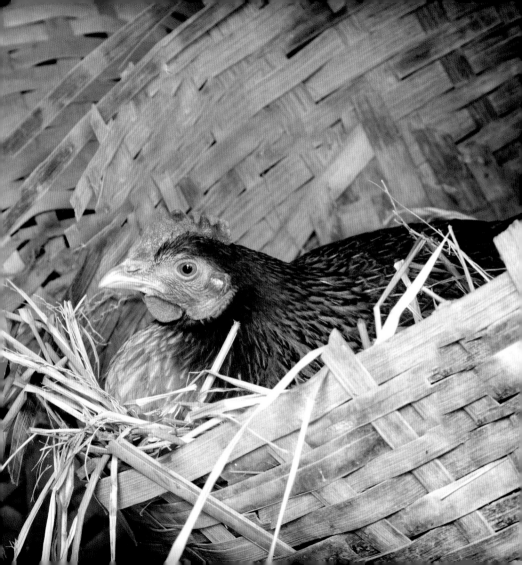

A hen will brood in a variety of places.

Chickens need a warm, dry place to sleep in winter as they can be prone to frostbite.

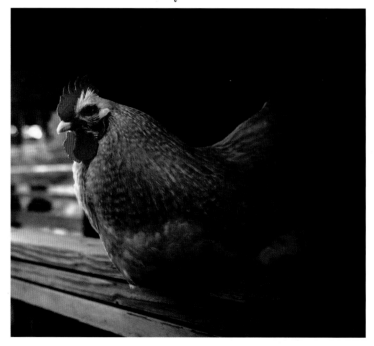

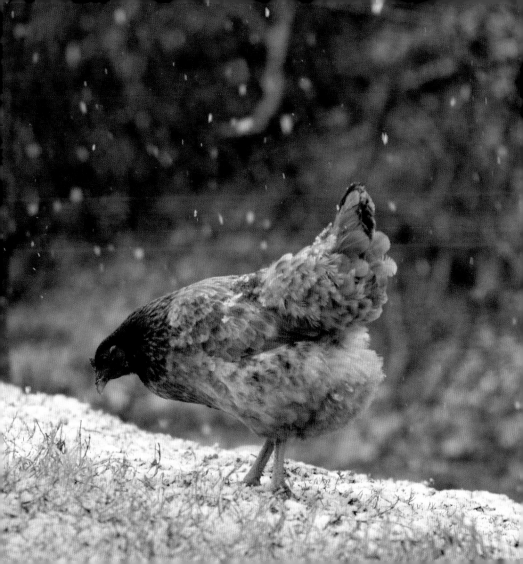

Chickens require a warm place to roost
at night. Good, safe housing protects
them from predators.

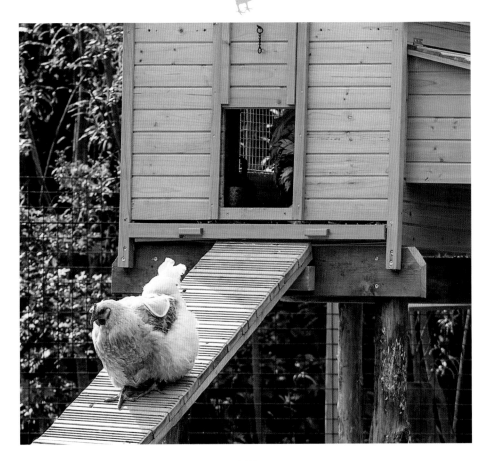

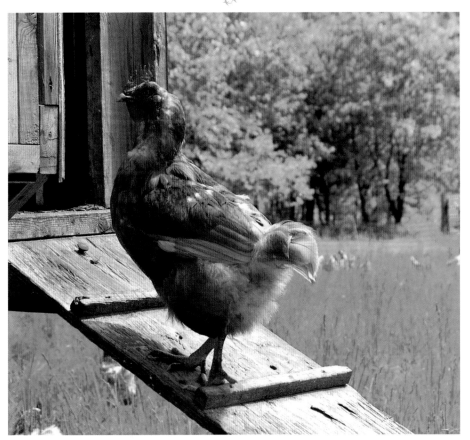

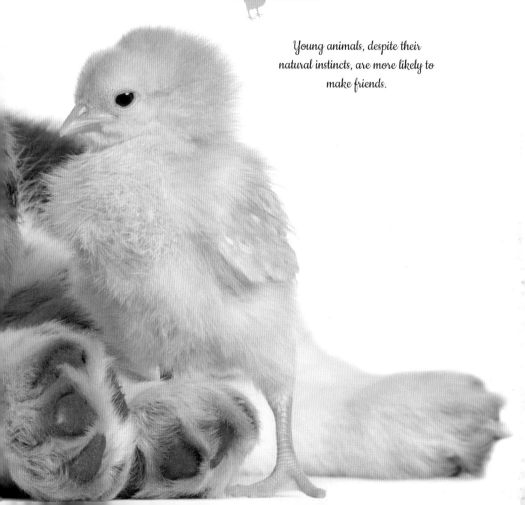

Young animals, despite their natural instincts, are more likely to make friends.

Like most areas of special interest, the world of chickens has its own language. Here, the most commonly encountered terms are explained:

Bantam: A small version of a domestic chicken, about one-quarter the weight of a standard bird. Some breeds are available in bantam form and some are not. A few breeds are only available as bantams. *(Below)*

Barring: A form of feather patterning in which equal-sized, alternating stripes run across the feather. *(Above)*

Beetle brow: This is a form of feathering that gives distinct, heavy eyebrows, such as seen in Malays.

Breed: In this context, a breed is any individual and distinct type of chicken,

reluctant to move off the nest until they are hatched.

Cape: Describes the feathers between the neck and shoulders. *(Below)*

Capon: A capon is a cockerel that has had its reproductive organs removed, usually at 6–20 weeks of age. Caponization produces less aggressive birds that may be used to 'mother'

such as a Cochin, a Leghorn, or a Rhode Island Red. *(Above: A Cochin chicken)*

Brooder: A heated system used for artificially rearing chicks.

Broody: Describes a hen's condition in the period during which she is intent on incubating her eggs and is often

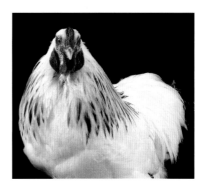

chicks. The practice of castration is now illegal in some countries.

Chick: This is a baby chicken, although the term is also used to describe the young of any bird species. *(Below)*

Cockerel: A young, uncastrated male chicken or rooster. *(Right)*

Comb: The fleshy structure on top of a

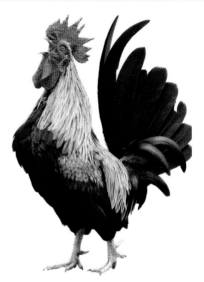

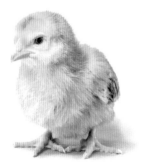

chicken's head. It may be variously shaped, and is usually bigger in the male.

Coop: This is a secure, dry, purpose-made structure in which chickens are put during the night, to keep them safe

from predators and the worst of the weather. *(Above)*

Crest: The feather arrangement on a bird's head.

Cross-breeding: The process of mating two different breeds or varieties to produce an individual with enhanced characteristics.

Dual-purpose chicken: This is one that is kept, or valued, both for its eggs and for its meat.

Dust-bath: A receptacle containing clean earth, sand, or wood ash in which a bird can 'bathe' to help rid itself of parasites and generally keep the feathers in good condition.

Earlobe: A patch of skin on the side of a chicken's head, below the ears.

Free range: Describes the lifestyle of a chicken that is allowed to roam freely over a reasonably large area of open ground, such as a smallholding, foraging for its own food as well as usually being provided with food by its keeper. The accepted maximum density for free-range birds should be 50

birds per acre (0.4 hectares). Today the term is often misused to give the impression that chickens are reared in 'ideal' conditions.

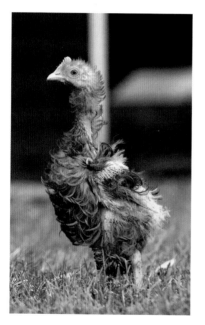

Frizzled: Describes a feather that has a pronounced curl, usually pointing toward the bird's head. *(Left)*

Hackle: A type of feather growing on the neck of a chicken.

Heavy breed: A breed of chicken in which the female has a weight of more than 5.5 pounds (2.5 kg).

Hen: A female chicken over a year old.

Hybrid: An individual created by cross-breeding to produce specifically required traits.

Incubation: The process during which a fertilized egg develops into a chick ready for hatching. This is often accompanied by the hen sitting on the

eggs to keep them warm. In other farming methods, artificial forms of heating are used instead.

Laced: This describes an attractive patterning variety seen on the plumage of some chickens, in which the feathers are edged in a different color than the rest of the feather. *(Right: feathers of a golden-laced Wyandotte)*

Litter: The covering material that is placed on the floor of the roost and run.

Mandibles: The upper and lower portions of a bird's beak.

Pellet: A small piece of specially prepared food containing all the required nutrients for a chicken. There are pellets designed for general growth, breeding, and so on.

Pullet: A female under a year old.

Run: An enclosure in which chickens can roam during the day. They are usually attached to, or incorporate, a roost in which the chickens can be locked safely away at night.

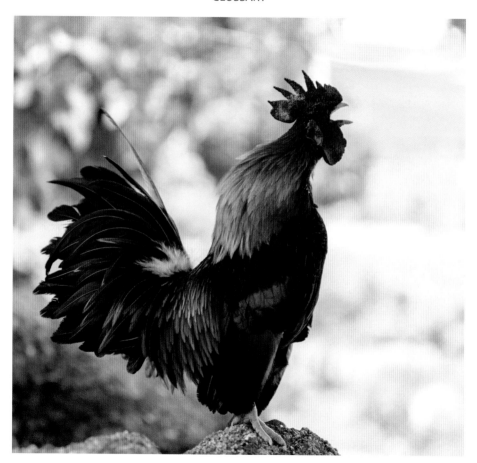

Rooster: An American term for a male chicken. *(Opposite)*

Saddle: A type of feather growing on the back of a chicken.

Scale: One of the many small, overlapping, keratinous structures that cover the legs and feet of birds.

Sickle feathers: The long, curved feathers in a male bird's tail.

Variety: Describes a specific variation, such as plumage color, plumage pattern, or comb structure seen within a breed.

Vent: The aperture through which eggs and feces are voided from the body.

Wattle: One of a pair of fleshy, usually pendulous structures that hang from the side of the mouth of a chicken and assist heat regulation. *(Below)*

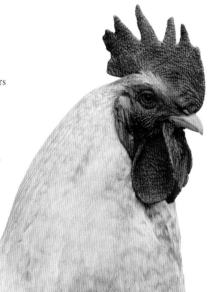

A

American Sebright (see Wyandotte)
Ameraucana 60
Antwerp Belgian Bantam 63
Appenzeller 64, 67–69
Asian jungle fowl 8, 14, 15, 20, 21, 26
Australorp 72–77
Ayam Cemani 78, 79

B

Barnevelder 80, 81
Barred Plymouth Rock (see Plymouth Rock)
Barthuhner (see Appenzeller)
battery chickens (adopting former) 51, 54
behavior 29, 33, 50
 aggression toward newcomers 32
 crowing 29
 fighting 29
 flock-forming 29
 pecking-order 29
Black Utility Orpington (see Australorp)
Braekel 82, 83
Brahma 84–90
Buckeye 90, 91

C

Campine 92, 93
Chabo (see Japanese Bantam)
Chantecler 94, 95
chicken houses or roosts 35, 40, 48
 draft-proofing and ventilation 37
 nest boxes 35
 perches 40, 43
 roosting poles 40
choosing a breed 48
Cochin 26, 96–103
combs, types of 22
 buttercup 23
 cushion 23, 25
 pea 23
 rose 23
 silkis comb 23
 single 23
 strawberry 23
 V-shaped 23, 24
Cornish 26, 104,105
Crèvecœur 106, 107

D

Dominique 108, 109
Dorking 110, 111
dust-bathing 40

Dutch Everyday Layer (*see* Hamburg)

E
earlobes 24
egg-laying 8, 14, 26, 46
 locations, 46
eggs
 artificial 28, 48
 fertilization of 28, 51
 hatching 28
 incubating 28, 51
egg teeth 28
evolution 22
exhibitions and shows 16, 17, 34

F
Faverolles 112, 113
feeding 44–46
 correct (amounts) 45, 46
 foraging 44
 grit 45
 habits 44
 regimes 45
 pullets 51
 water dispensers 44
fighting 29
Frizzle 114–117

G
Grey Chittagong (*see* Brahma)
grey jungle fowl (*see* Asian jungle
 fowl)
grit 45

H
Hamburg 118–123
handling chickens 54, 55

J
Japanese Bantam 124, 125
Jersey Giant 126, 127
jungle fowl (*see* Asian jungle fowl)

L
Leghorn 50, 128–131
longevity 33

M
Malay 132, 133
Marans 134, 135
Miniature Cochin (*see* Pekin)
Minorca 136, 137
Modern Game 138, 139
Moonie (*see* Hamburg)

N
New Hampshire Red 140-141

O
Old English Game 142–143
Orpington 144–149

P
parasites 40
pecking order 29
Pavlovskaya 150-151
Pekin 152–157
pet chickens 33, 34
Phoenix 158–159
Plymouth Rock 160, 163
Poland 164, 171

R
Red-Faced Black Spanish (*see* Minorca)
red jungle fowl (*see* Asian jungle fowl)
Rhode Island Red 172–177

S
Scots Dumpy 178, 179
Sebright 180–183

Sebright Cochin (*see* Wyandotte)
Shanghai (*see* Cochin)
Silkie 24, 49, 184–191
Spitzhauben (*see* Appenzeller)
Sussex 50, 192, 193

W
wattles 24
Welsummer 50, 194, 195
Wyandotte 196–199